75-00

Black Dog Publishing Limited
London and New York

What is drawing?

What is drawing?
Three practices explored
Lucy Gunning
Claude Heath
Rae Smith

Edited by Angela Kingston
Designed by Gavin Ambrose
Published by Black Dog Publishing Limited
2003

Architecture Art Design Fashion History
Photography Theory and Things
Black Dog Publishing Limited

5 Ravenscroft Street
London
E2 7SH
UK
T 44 020 7613 1922
F 44 020 7613 1944
E info@bdp.demon.co.uk
www.bdpworld.com
ISBN 1 901033 14 7

British Library Cataloguing-in-Publication Data.
A catalogue record for this book is available from the British Library.

Copy editing by Ian Hunt.
Transcriptions by Elizabeth LeMoine.
Administrative support by David Dibosa and Adam Lloyd Monaghan.
Photographs on pages 36–43 are by Claude Heath.
Photographs on pages 64–67, 70, 76, 79–86, 88–90, 91 (Top),
92–101, 105 and 157 are by Lucy Gunning.
All other photographs are by Nick Manser, except where indicated.
Cover image: Lucy Gunning at work.

The Centre for Drawing is a Wimbledon School of Art Research
Centre project. It was curated by Angela Kingston 2000–2002.

What is drawing?

Three practices explored: Lucy Gunning, Claude Heath, Rae Smith

Contents

Preface: What is drawing? p.10
Michael Ginsborg

Introduction: Arriving and leaving and doing something in between p.14
Angela Kingston

Claude Heath interviewed by William Furlong p.18

Perspicuous by their absence: the drawings of Claude Heath p.32
Andrew Patrizio

Lucy Gunning in conversation with Michael Ginsborg p.58

Lucy Gunning: Wearing flowers, drawing flowers, looking at flowers p.72
Irene Amore

Rae Smith in conversation with Hilary Baxter p.106

Rae Smith: What drawing feels like p.118
Neil Bartlett

Drawing things in, sketching things out p.152
Erika Naginski

Preface: What is drawing?

The work of Claude Heath, Lucy Gunning and Rae Smith, specifically in the form of the residencies they undertook and the resulting exhibitions they held at the Centre for Drawing at Wimbledon School of Art, is the starting point for this book. Its purpose is to examine, through that work, the media, activities and practices that may be considered to fall within the scope of drawing. This book acknowledges and addresses the fact that the conditions under which drawing is made and shown are, in common with other forms of art, "newly complex".[1] This complexity arises from three main factors. Firstly there is drawing's continuing relationship, and even dependence, on its earliest material forms and processes. But then, in contrast to this, there is the fact of its transformation in the latter part of the nineteenth century and during most of the last century, at the hands of artists from Redon, Seurat and Cézanne onwards, and through numerous subsequent bodies of graphic work, into an experimental form which became instrumental in both generating, and coming to terms with, changes in visual art. Lastly, these changes in themselves have led to the development of practices that purport to be, or are construed as, drawing – practices that have left the page altogether, and are performed, physically or electronically in the spaces of architecture, installation, live art, the screen, or the landscape.

But are these practices really drawing? By no stretch of the imagination can they be called drawing if we accept the 'terms of engagement' that I offered when I wrote, with deliberate provocation, that "Paper is not the only support for drawing but it is by far the most widespread. Drawings are made with graphite, charcoal, chalk, or ink and with brush or pen. Drawing is flat and monochromatic and it does not predominantly address colour relationships."[2] I went on to make the point that it was this limitation of means that gave drawing its significance.

What is at drawing's centre? No one thing, for certain. Its inclusivity is too great for that to be true – what cannot be represented by a drawing? But its inexhaustible capacity for invention and change must, I feel, be attributable to its two-dimensional format and narrow range of materials. Put another way: drawing's value has a lot to do with this inclusivity, with the range of content that it can deal with, and not so much to do with material experimentation.

The artists were chosen with the intention of exposing the differences and conflicts inherent in current drawing. We hoped that we would learn something new about drawing from the way that each of the artists tested it and put it

under pressure in their work. It is also the case that artists were considered in terms of their proximity to, or distance from, the normative or traditional hypothesis about drawing that I have offered.

Claude Heath works by experimenting, within a 'classic' drawing process, with relationships between sight, touch, and mark. His spectral line drawings bear a resemblance to technological diagrams and doodles, and they also provide us with a new take on Matisse's famous statement: "One must always search for the desire of the line, where it wishes to enter or where die away."[3]

Does Lucy Gunning draw at all? We have to ask this question and ask what asking it tells us about what we think drawing is. What did Gilbert and George mean when they said that they were sculptures? Gunning treated the studio at Wimbledon as a kind of total artwork. This way of working, dealing with discovery at every moment, generates debate about drawing's proper territory, its expansion, and its limitations, both materially and emotionally.

Rae Smith, in drawings infused with descriptive poignancy, showed us, as a theatre designer, how drawing could have an instrumental function in the making of theatre, as well as a personal role in the telling of stories. Her work made a convincing argument for the fact that the full range and richness of drawing today is not to be seen by looking only at what artists do. The drawings of designers and architects, for whom function, the relationship between the two- and the three-dimensional, and the use of new drawing technologies are crucial considerations, contribute equally to drawing's changing vocabulary.

By participating in a residency programme, artists declare a commitment to sharing their practice. The relationship between the space of that practice and the spaces, or arenas, of critical enquiry and procedure that they are the subject of, or subject to, provide, as is the case for all the inhabitants of an institution, a set of tensions that need to be continuously and personally negotiated. Drawing offers and has always offered artists a very particular kind of working space, one that is often of such modesty of scale that it belies the possibilities that lie within it, and in which difficulties seem more amenable to resolution than elsewhere. It is a liminal space where transformations seem to emerge with more fluidity, a space where the 'what would happen if?' questions are asked material in hand, and may, or may not, be accompanied by sets of conditions about how, or when, they might be answered. It is a model working space where process can run the gamut between calculation

and improvisation and be privileged above product – where technique can be masterly, or desultory, quite possibly in the same drawing. Finally, it is a space that might enable separation (if only temporarily) from the evaluative apparatus and acquisitive grasp of the academy and the art market, however their differing pressures are experienced and indeed internalised by artists.

Prompted by some of Stephen Melville's ideas in his essay "Counting/As/Painting", we have ourselves needed to ask the question: what 'counts as' drawing.[4] By focusing on a variety of current practices this project understands its purpose, not simply in terms of giving an account of the diversity of those practices, but as something that will offer possibilities back to drawing itself.[5] This involves taking risks – some would say taking liberties – with what counts as drawing. It also involves engaging with drawing dialectically; that is to say resisting, and re-examining some of our assumptions about drawing – for example its supposed revelatory capacities, its pedagogical centrality, and its material formats. In an analogy with creative practice as a whole, this would, we felt, be the only way of developing new understandings of the subject, and taking critical responsibility for, rather than expunging, the restlessness of drawing's enquiry at the service of an equally restless visual culture.

Michael Ginsborg

1 Melville, Stephen, "Counting/As/Painting" in Armstrong, Philip, Laura Lisbon and Stephen Melville, *As Painting: Division and Displacement*, Cambridge, MA: MIT/Wexner Center for the Arts and the Ohio State University, 2001, p. 5.

2 Kingston, Angela, ed, *The Centre for Drawing: the First Year*, London: Wimbledon School of Art, 2001, p. 7.

3 Flam, Jack D, *Matisse on Art*, Oxford: Phaidon, 1978, p. 43.

4 See Melville, "Counting/As/Painting".

5 The Centre for Drawing, which started in October 2000, runs three drawing residencies during the academic year. In the first year the participants were Vong Phaophanit, Ansuya Blom, and Alexander Roob.

Rae Smith's work table

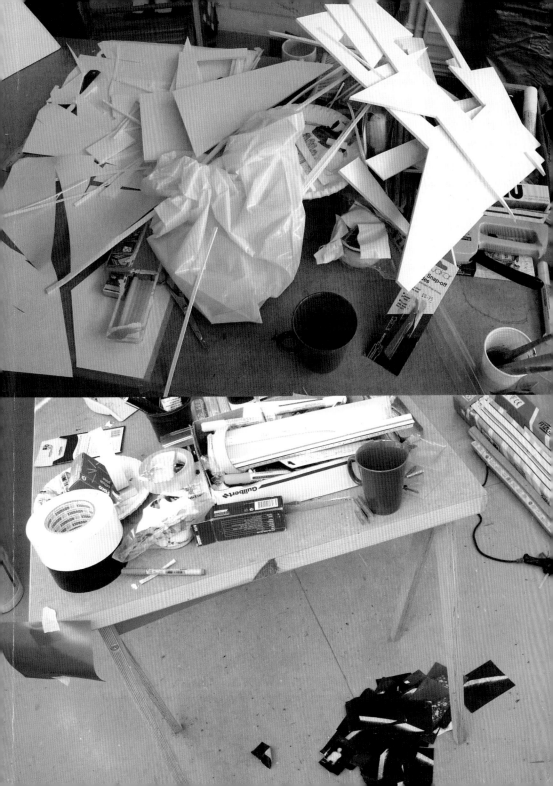

Arriving and leaving and doing something in between

The drawings in this book were made, rather unusually, under identical conditions. Claude Heath, Lucy Gunning and Rae Smith, in turn, spent six weeks drawing in the same studio. At the end of each stint, a selection of works was exhibited, in the same space in which they were drawn, the studio having been transformed into a gallery for a short interval.

It follows that each of the three bodies of work was unusually 'at home' in that space. The sheets of paper, unrolled and smoothed against the walls and floor of the room, had become a kind of second skin. Rae Smith made some of her drawings directly onto the walls; Lucy Gunning's work sometimes depicted the room itself: all three artists made work in which the scale of marks and images was, in some however subtle way, determined by the size of paper (A1, A4, A5), combining with the dimensions of the room. There was none of the initial foreignness that can be felt when art arrives from elsewhere for an exhibition.

Even from the outset, it was clear that there was going to be a vivid correspondence between the studio-gallery and the drawings made there. The space of the studio and the space of the page became psychologically linked; they acted as metaphors for each other; at times they became conflated.

Each of the artists was both excited by and apprehensive of the emptiness of the studio as it first appeared to them – in much the same way that a blank sheet of paper will give rise to both anticipation and anxiety. Sometimes, at the beginning, the entire six weeks felt like a single drawing that could go wrong, and that precious, indelible time would be wasted. Leaving was charged, too. The three artists all talked afterwards about missing the space: like finishing a good drawing, they were relieved and happy that it was done but regretted having to come away from it.

In the drawings Claude Heath made, there are two kinds of lines: those relating to the plants he was depicting, and lines that mark his arrivals and departures, his beginnings and endings. Clamping a drawing board at right angles to him and to one side, so as to keep the drawing out of sight while he was working on it, he would make a steady horizontal line that traced his point of entry at shoulder height. He has talked about this line as a means of "tying the drawing into me, connecting it to where it's drawn from"[1]. In the 'four-fold' drawings – three-dimensional works that were made with both hands – there are lines that run along the top edges of the paper structures that indicate

where Heath "handed the drawing over to the other side, the other hand". This attitude – of the paper being a space to be occupied through drawing, with a trail of lines leaving evidence of this – was further revealed by the artist's observation that "many of the drawings are circular. The movement of the hand is around the paper. It's a flat surface that you can't go into, you can only go around it."

Here, the question 'What is drawing?' can be answered readily, and with reference to the most traditional and typical of definitions. Heath's drawings are made using the hand; they involve linear markings; they are on paper; they grapple with the depiction of three-dimensional objects on a flat plane.[2] There is also an immediate and specifically *traceable* connection between the artist and what he has made. Further, these works have led to the creation of paintings, and this, again, means that they readily fit our usual understandings of drawing: as he says, a good drawing is one that he "wants more out of". But although in some ways preparatory, drawing has a primacy for him: "drawing is the moment, painting is the revisiting of that moment". This sense of its value, too, has long been considered an essential attribute of drawing.

Notwithstanding the unorthodox and inventive methods of representation that Heath explores in his work, his occupation of the space of drawing is assured and uncontroversial. It follows that his occupation of the drawing studio was uncomplicated and purposefully intense. Lucy Gunning's time in the studio had an intensity of a different order. She came with a prevailing sense of drawing as art at its most provisional, insecure and open (associations with materials and techniques being secondary). But since these are attributes of the video and installation art she is best known for, what would distinguish what she now made as drawing?

She said, at the beginning, "I will use my time to think about what I do in relation to drawing. I can't say it will definitely be drawing in terms of pencil on paper. I don't rule it out. But I don't *know*."

In the first days, Gunning made playfully earnest photographs of herself drawing: self-portraits and flower studies, exercises that tried to pick up the threads of a sure knowledge of drawing, perhaps. There were also rapidly drawn 'ideas' drawings, for projects she left unrealised: a drawing of people crowded into the studio, for example, which she was thinking of staging as a performance.

What gradually emerged was the notion of "treating the room like a page". White arrows were taped onto the floor; objects were arranged and rearranged, with the assertion that "placing things is a drawing"; finally, and most importantly, the artist criss-crossed the space, pursuing trajectories, creating narratives, now and then pausing to leave a significant imaginative trace. Gunning photographed all of this, using a time-delay mechanism on her camera to create both single-frame images and works in series which document these 'drawings' that were made into the space of the studio.

I am conscious here of my use of inverted commas. The question is: does what Gunning did really count as drawing? There are certainly many qualities that make this work very *like* drawing. The artist's actions within the studio were made with an unquestionable immediacy – a key attribute of drawing. Thanks to the photographic documentation and the simplicity, in practical terms, of what has occurred, the work is *traceable* (a feature of drawing that was cited in connection with Heath's work). Gunning also asserts her first-hand involvement and her primacy within this work to an unusual degree, distinguishing it from most of her previous projects: it is, emphatically, *her* actions that we see, *her* curiosity enacted. Like Heath, with his lines that 'tie' the drawings to him, she makes entirely visible her attachment to this body of work.

Another characteristic of drawing was explored in the manner in which Gunning exhibited her work. Instead of being framed, the photographs were taped to the wall; she left her tripod in place, together with some lights, as if she might at any moment pick up where she left off; there were clues to other works which might be made, which included a megaphone left under a table, ready to be used as a prop. The artist wanted to suggest a functional space, one more like a studio than a gallery, in keeping with her idea that "drawing is something that happens on the way to making things".

Until quite late into her residency Gunning talked about making a video. We discussed the equipment she would need and an editing suite was booked in readiness. However, the artist wanted to keep things open and exploratory and subject to rapid change – and this, in the end, ruled out making and editing a video. By default, almost, photographs were made instead of work that would require any second-stage involvement on her part. It was significant, too, that she had her photographs developed straight away, using local one-hour processors. And she bought and exposed copious amounts of film. She was *drawing*: engaging with a cheap, everyday process which gave (almost) instant results that she could quickly react to.

It is possible that some of the series of photographs will be revisited and videos eventually made that bear a relationship to them. This would, in part at least, confirm their status as drawing. But Gunning is reluctant to speculate on this. It is impossible to predict whether these works are preparatory in nature, or to say if they currently exist as final pieces. Paradoxically, this may even serve to strengthen the idea that these photographs are drawings, for this is the position taken by many artists with more typical pen or pencil on paper drawing practices.

I am inclined to take on trust how artists categorise what they do – especially since, in most cases, they are extremely reluctant to do this. The naming of all things changes. Language evolves. When electric fires were introduced, I suspect there were all kinds of qualifiers that distanced these objects from coal and wood fires flaming in the hearth. But now we speak unselfconsciously about 'switching the fire on'. Gunning has interpolated photography into drawing, through the nature and particular circumstances of her involvement with the camera.

Drawing, using a pencil or pen on paper, is central to Rae Smith's practice as a theatre designer, and it has a particular importance for her in connection with the devised theatre for which she is best known: "Working with Théâtre de Complicité, I drew for five weeks. It was the only way of taking in improvisations, and secretly giving them a structure through the drawing."[3] The drawings, then, become a focal point in discussions with the actors and director and other collaborators – and during these conversations she continued to draw in response to suggestions and ideas. She has talked about how her drawings allow her to work in such a way that her thinking remains open and fluid (which chimes precisely with Gunning's view of drawing). Written notes, she feels, tend to fix ideas and can introduce a sense of intellectual closure, not only for herself but for the actors too.

The studio, she decided early in the process, would become a place for her memory, for herself in fact, through drawing. The momentum Smith spoke of quickly took her back to a traumatic event she was reluctant to remember: some years ago, she witnessed a woman killing a child with a pair of scissors. For a time, this memory threatened to block her completely, yet in the end it gave rise to a

remarkable series of drawings. In the studio, she made drawing after drawing that recovered the event, the spontaneous lines and smudges and stains retrieving the impossible, suppressed emotions of it: the woman's self-pity, her infantile anger, her self-obliteration through violence, the tenderness the woman had for her newly dead child.

Drawing is, here, a remarkable means not only to inhabit but also depict previous experience (it is impossible, of course, to photograph a memory). Smith's responsiveness to the spontaneous marks which occur in her rapid drawings has given access to the range of emotions she witnessed and felt during the murder and its aftermath. One by one, these small drawings were made and the memory laid down. The strange waver of a line as it appeared before her on the page became, actively, the means to remember (and cast off) a sickening moment. In places, her repulsion has blotted the paper. In others, the ink has run down the page in mourning. A moment has come back again and again in many different drawings, the trauma of it demanding repetition in order to discharge itself.

The way Smith chose to exhibit these drawings was both unusual and apposite. They were placed, loose, on a low shelf between large wall-drawings. Visitors would pick up a pile and go through them, reordering them each time. They were encountered like our own distant memories, out of sequence and confusing at first, then gradually shuffling themselves into order.

The experience of working for those six weeks in the drawing studio was, for Smith, "about leaving some things, about other things I want to do more with". She has left some things on the pages in that room (the repression of her murder memory, she hopes) and made preparations, like Heath, and perhaps also like Gunning, for other things to come.

In seeking to answer the question "What is drawing?", a diagnostic approach has been taken. There are interviews with Lucy Gunning, Claude Heath and Rae Smith, and essays by writers who were asked to scrutinise the drawings the artists each made. The emphasis is on elucidating what occurs within and through their particular practices of drawing. In other words, we have not sought general definitions of drawing in the abstract. Sometimes the fact that these works are drawings (or are arguably drawings) becomes secondary to the discussion, and this is important. For these drawings are experienced first and foremost as

art, and it is in this sense that they are often attended to on these pages. For to be too conscious of this work *as drawing* would, I feel, threaten to attenuate the discussion. The resulting interviews and essays therefore flow freely from the experience of making, looking at and understanding these bodies of work.

Heath, in his interview with William Furlong, describes his involvement with drawing as a process that he can deliberately constrain in order to liberate unforeseen pictorial potential. Andrew Patrizio offers philosophical interpretations of Heath's unusual methods and discusses his drawings as a unique form of knowledge. Gunning, interviewed by Michael Ginsborg, talks about drawing being simultaneously a trace of events and a state of imminence: it is her attitude, and ultimately what happens within and through a work, that defines it as drawing – rather than the materials she uses. Irene Amore continues this discussion of drawing as a state of mind, and describes Gunning's use of the camera within a constellation of changing relations between artist, subject and viewer. Smith, in conversation with Hilary Baxter, speaks about drawing as a creative tool to memory and imagination, most often used by her in collaborative projects. Neil Bartlett, a theatre director who has often worked with Smith, responds to this unusual solo outing for her vigorous engagement with drawing.

Finally the art historian Erika Naginski, in a subtle thinking through of the work of the three artists here, looks again at how drawing manages to forge an immediate link between thinking, sensing and showing, and at its ability to body forth the "inmost life" in things: those qualities that make it still the medium that takes (and also quickens) the pulse.

Angela Kingston

1 All quotations from artists are from conversations with them.

2 See Rawson, Philip, *Drawing*, Oxford: Oxford University Press, 1969, especially chapters 2 and 3.

3 In devised theatre, the director, designer, actors and other participants work collaboratively, using improvisation and other open-ended techniques, in order to develop understandings of a play or opera and work towards its realisation.

— 15 m

Claude Heath interviewed

— 15

William Furlong: Was there a particular project that you had in mind before you started to make these drawings?

Claude Heath: Having worked on a water fountain as a way of tackling an open form, a natural thing was to consider these very delicate, very complex objects – ordinary house plants – which I bought locally, knowing that I was going to bring them to the studio and draw from them. Plants are semi-opened, semi-closed, very broken up, very complex things. So I arrived knowing that I wanted to draw the plants and to try this idea of drawing them from underneath, to draw in a tactile way, but using my eyes.

WF: You've made them by drawing on the other side of a sheet, on the side you can't see, or actually underneath the drawing table... I wondered if you could talk a little bit about what interests you in that kind of method?

CH: It's a mystery to me why I find it interesting. It's actually quite hard to talk about, but I can say that it creates a bit of a neutral space, it clears the ground as much as possible, it helps me to get rid of all the stuff that *I think* I want, and allows something else to happen.

WF: The Western tradition of art arises out of Renaissance concepts of looking at something, and a fixed picture plane that organises perception of the subject. You didn't actually come through art school, so you're not embroiled in that history, although obviously you know about it. You're not, therefore, recording something that you're looking at in a way that brings along the baggage of history with it, in terms of a frontal perception of that particular object.

CH: There's an interesting visual thing that happens where, if you have a lot of different perspectives or different senses working together, you get a foreshortening of all these experiences into one flat image. But they can somehow work with each other to produce an over-arching visual sensation. It is as if, while you're making the drawings, you have to drop your intellectual sensibilities. So you might have conflicting perspectives or senses in an image but you could still see that while each on their own makes a certain sense, when taken together the mind can actually interpret them in its own way.

WF: But when you're making a drawing, you can't actually make aesthetic judgements of it.

CH: Not of the drawing that I am making. But it's a step-by-step process: it might be that there is a certain point in the process where you have a very great clarity about something you want to put down. At other times, you just have to do the best you can. And it's those things that

produce, all together, this conflict: there's no single point of view. It's as if the object has been conceived from many different points of view, and not in a literal sense: thoughts and feelings about that object are there too. When I drew the Willendorf Venus, someone said "you couldn't possibly draw that just from touch only". Of course, that was like throwing down the gauntlet, so I had to try. But to draw it and then to turn the object became fascinating because the perspectives of this figure that was turning became very, very condensed. That also happened when I was doing a series of drawings blindfold, of objects I had never seen, and in some of the plant drawings as well, where you have a sense of looking at things through a different kind of prism. And that just interests me. It's how to arrive at a point where something like that can happen. You have to set up all these rather elaborate methodologies.

WF: It seems to me you're revealing something much more to do with an essential set of properties of the object you're working with and you're not, as has sometimes been said, at the mercy of the particular.

CH: That's true. But if you're using touch only, you're at the mercy of your fingertip which is the only thing you have in contact with the object. And the other hand is holding a pen, is making a mark. So there's not much sense of what's gone before or what's coming after. It's a lot of particularities all put in together.

WF: I think traditional representation isn't an issue for you. You practise another form of representation that has its own kind of competence. You feel, you touch the object, you process that information, and then you make a mark or you trace that sensory experience. Do you have a system, by which you then translate it into the hand that's making the mark?

CH: There's no particular logic, but before I start a drawing I know that I want to look for certain things: where the horizontal contours meet the verticals on a head, for example. So you start looking for things that might fit a category. But how you put that on to a sheet of paper, which is next to the object, is another thing. And maybe that's where the drawing arm and my attitude comes in, because I'll be looking for things already, but then selecting what to draw. So there's a filtering process: the objects are so complex that one couldn't put down everything there is to say about them.

WF: But you do actually move them round, don't you, 360 degrees?

CH: Yes, as if by drawing and turning the object while you're drawing it,

you can then experience it really fully in the round. It's a way of coming to know something very well; you have to get to know it over a period of time. So, for instance, the Willendorf Venus: I drew it five times but turned it each time I drew it, and didn't look at the drawings until all were complete.

WF: In that case did you know what it was that you were drawing?

CH: I did, yes. And there is a point at which, if you draw an object for the first time, you are totally innocent about what this process is going to do for it. If you're drawing it for the second time or the third time, you're then into a different level of chance. But it's very often that first drawing – like the one of the tiger that was leaping – that contains the most possibilities. Whereas the later drawings maybe had become a bit more selective. So it's not as if I am always setting out to deal purely with raw chance. I'm actually setting myself the target of working with different kinds of chance and allowing them to interact with each other, as you can see from the plant drawings.

WF: There's an interesting parallel with some forms of medical scanning, for instance, where you're taking a kind of a 360 degree view of an object. But it's not quite like that. Because you don't rotate objects by a mathematical set of principles: you're 'scanning' in an intuitive way, nevertheless.

CH: It's the choices that you can make beforehand, like where to start on the page; where to start on the object, too. Those are almost the mathematical, calculated part of the procedure, setting the givens for something to unfold from.

WF: How do you know when the drawing is finished or complete?

CH: "When do you stop and why?" Of course, it's a good question. There's no real answer except to say that it's as if you're writing a letter and before you reread the letter you want to know if you've put everything in that you want to say to this person.

WF: But do you actually look at the drawing before you make that decision?

CH: No. Because then you'd lose your state of innocence about what you'd drawn. To then go back and add something would be a kind of tautology.

WF: But you must have a sense of time that you will spend, a kind of accumulated knowledge about approximately what will work with a particular drawing.

CH: That's a possibility, but then each time I change the parameters. So with the head, I would move the head or drop it down, change the

rules so that the drawing would be passing through a different set of possibilities. I think I reached a point where I realised that; OK, the drawings are interesting, the process is interesting, but more importantly there is a way of interacting with your thoughts, with the images, the thought process behind how you choose to draw.

WF: Does the experience of the surface when you are making drawings blindfold by touch lead directly to the mark with the other hand, or is it mediated in any sense? I mean, do you pause and think "maybe I should do this or do that?"

CH: No. It's a bit like juggling: if you stop and think about it, you just wouldn't be able to do it. So, when I was drawing the plants, I noticed – because I decided to draw in two planes, underneath the table and on an upright surface next to it, but simultaneously – that I'm drawing a plant-leaf that's shaped as if seen from above: underneath I'm drawing it in that projection, while on the side I'm drawing it as a sort of a narrow surface as if it's seen from the side. There's no time to actually consider all this when you're doing it. Which could be described as another strategy to pull the rug from under myself a bit, but not so much that I wouldn't be able to function.

WF: Are you always looking for strategies to do that?

CH: The thing that interests me is what happens when something's just slightly out of your reach, slightly beyond your control. It's interesting how an image can then by chance enter into another significance which one hadn't quite foreseen. That's certainly the case for me with some of the plant drawings that I've made here.

WF: But you set up conditions to make the drawings, you set up procedures and you set up physical kinds of circumstances that, as you say, often pull the rug from beneath your feet so that you don't become repetitive. But what are the processes that you then apply when you see the drawing?

CH: If you've removed your critical sense from the process of making, then you have to let the critical sense, when looking at the results, stay in abeyance. So, it's as if all the drawings are equally correct or incorrect. They each have equal status. But it's then interesting, going back to what we were saying about how you analyse a drawing, what you can then do with it. And it's the drawings that suggest other spatial possibilities to me which I will then choose to develop into other works. When I go back to my studio, I'm going to look at which of the drawings suggest the particular spatial conundrums that need to be unravelled,

and at which drawings contain most of those kind of possibilities, that will in turn suggest new ideas for drawing.

WF: There's something about them which is not, necessarily, to do with the trajectory that you draw from touch, but with the intersections of the lines, which could in a sense create the drawing. It reminds me of some of the diagrams that scientists create, which are often to do with intersections of lines, when they try to visually describe brain functions or principles of natural science.

CH: One recent painting looks a bit like one of those chambers where they shoot atoms through gas clouds, and you see the trails: you don't actually see the object, the atom itself, but you see where it's been. As if a drawing had passed through itself. It's quite extraordinary.

WF: Are you interested in the science/art analogy and the crossovers in relation to what you're doing?

CH: I am. I even talked recently about doing a collaboration with a scientist who researches eye movements: the idea was to use just my eyes to make drawings, so that there would be no intermediary. It was a nice thing to think about and it was almost like that was enough. Actually I've taken some of those ideas and put them into these drawings of plants because a lot of lines represent the movements of my eyes tracing these complex shapes... it's been very demanding to see if my hands can keep up. Because my eyes have been tracing contours like my fingers used to. It's interesting to think about scientific analogies, but the outcomes are not science, but something that has its own mode of knowledge. That is where what I do it fits in.

WF: Thinking about your work, artists who come to my mind are: Mondrian...

CH: Ah!

WF: ... in terms of linear structures and intersections and so on. Giacometti, of course. And analytical cubism, which attempted to see in four dimensions, in the way your works are made in time. How do you relate to those references? Do they have any resonance?

CH: They certainly do. Giacometti is, of course, a fantastic draughtsman. And the thought process behind it was just as interesting: the way his sitters would always have to be a certain distance from him and they would have to be frontal, which was quite unlike his process of making sculpture in the round. It's also significant the way he connected with someone like Bacon who, again, is an early influence or point of reference, probably on a lot of us. Bacon's statement that we should work off our nervous systems, or that he would work off *his* nervous system... in a way I was interested to know if that could be applied literally,

through working with the sense of touch. And you could say that the same applies to eye movements as well: it's an extension of our nervous system. I think a lot of the work that I'm making does have a sort of a nervous quality to it. There's a lot of movement and a lot of force being packed into the drawings, whereas the paintings try to slow things down a bit. Another hero of mine would be de Kooning: the way he thinks and uses gesture, especially in the late works, which I know that some people aren't into that much. I find them very interesting and it's an ambition of mine to work on a three-dimensional equivalent – a drawing equivalent – of that kind of gesture in space.

WF: I wondered if you could talk about how you think drawing – the state of drawing – 'is' and what its importance is, because drawing is used, as we know, in many different ways by artists, and more often than not it's a kind of preparatory process, or an analytical process.

CH: It's my personal view that there's a big gap that's opened up between drawing something, representing it, and the fact that you have all these other technologies which are burning the trail ahead of us – digital cameras, 3-D technology and so on – that are capable of rendering something in a completely determined way. I'm talking about being able to think conceptually about an object, and to draw it as if you were a computer, but without the mathematics. It's a very rich area that drawing just needs to be pushed into and not be embarrassed about trying to represent something and in the process represent yourself too. It seems to me that's a way I see that drawing *can* go. Take *Toy Story*, for instance: it's a fantastic film anyway, but it's pure drawing. It just lacks the handmade quality, or is completely pinned down, you could say; and more importantly it's not so much interested in a 'crisis of representation' itself; it's telling a story. I just like the idea of drawing being able to tell a story through itself, by itself.

Comment from the audience: I do think the analogy of the atom is really appropriate, because in your work there is always a space between the object and the drawing, and the two cannot coexist at the same time visually. When you see the drawings of the plants – and I did recognise one of the plants – I had a feeling that it was the trace of something that had been there, but that wasn't anymore. The presence of something is really vibrant.

CH: That's true. Though the presence belongs to the drawing. It doesn't necessarily interest me whether a plant that I've drawn corresponds really closely with the drawing. I think with the cross-section drawing that folds into itself, it's a good example of how you get a sense that a

drawing surface has been dropped into a situation and a feeling of having taken away a record of something. Because of the way that they're made, it's as if you're projecting an image of this object onto the surface and, again, the question is "how much can you put into an image?" Before you've looked at the drawing it feels as if there might be everything in the world possible to say about this object in the drawing. And then you look at it and you realise that it's actually saying something else. There's always a shortfall between what you think and what you get: you're not having it all on a plate, and that is positive.

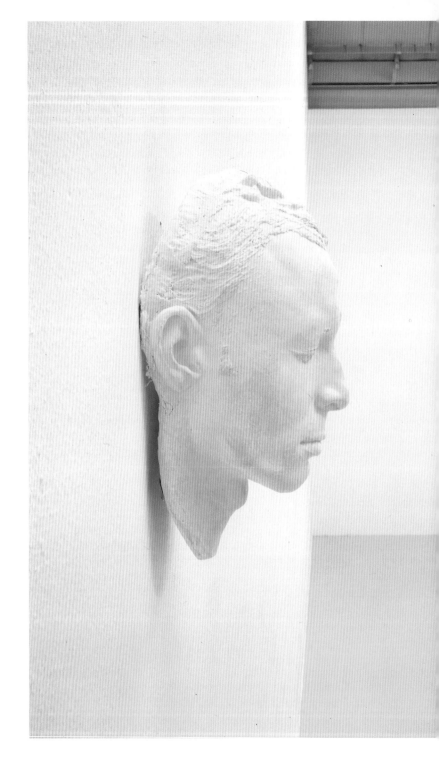

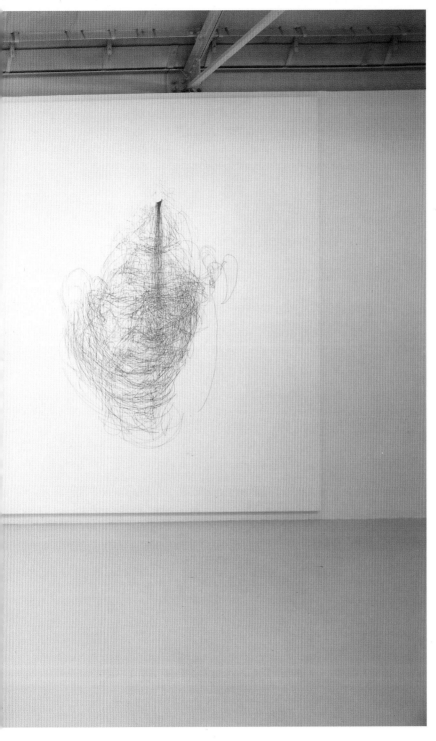

Tender Ground

chalk and oil-based
paint on acylic on
canvas, plaster cast
and blindfold, 1996,
one of four canvases,
each 376 x 315 cm,
*Young British Artists
VI* exhibition at the
Saatchi Gallery,
London

photo: Stephen White

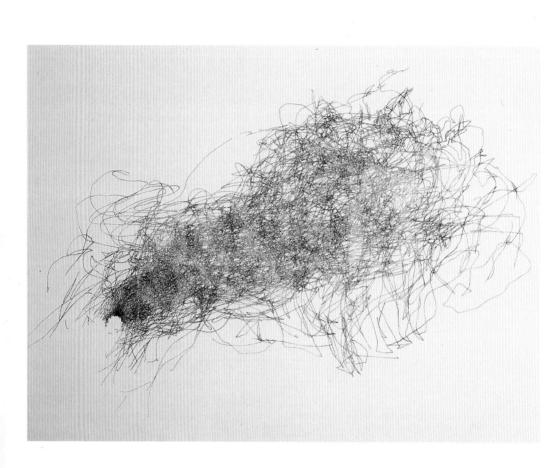

Tiger and Prey

wall drawing, black spray paint, 1997, 210 x 430 cm, *Antechamber* exhibition at Whitechapel Art Gallery, London

photo: courtesy of Whitechapel Art Gallery

Willendorf Venus

oil-based paints and chalk dust on canvas primed with acrylic, 1997, 150 x 340 cm, collection of Walker Art Gallery, Liverpool

photo: courtesy of the Board of Trustees of the National Museums and Galleries on Merseyside

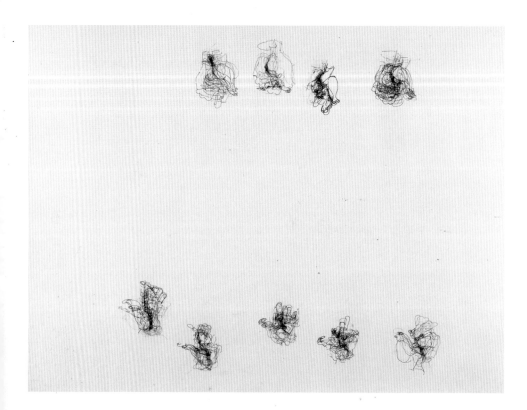

Epstein's Hands

ink on paper with
Blu-tack, 1999,
114 x 148 cm

photo: Peter White

**After Anthony Caro's
Smiling Woman 1956**

wall drawing, acrylic
on emulsion, 2001,
dimensions variable,
Pekao Gallery, Toronto
(and versions at
Changing Room,
Stirling and Talbot
Rice Gallery,
Edinburgh), courtesy
of Atopia projects

photo: Fraser Stables

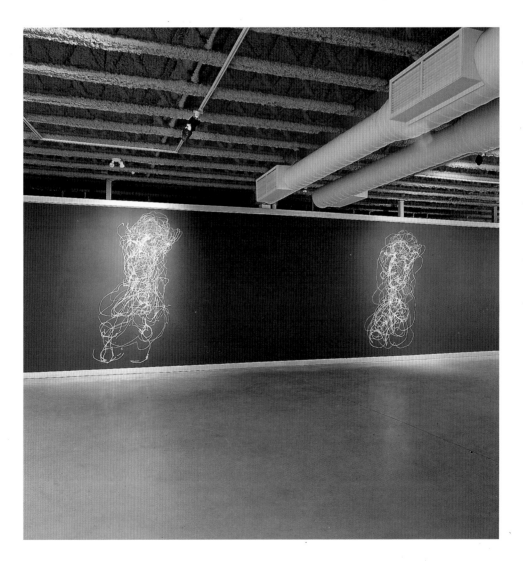

Perspicuous by their absence: the drawings of Claude Heath

My interest in Claude Heath's work originated at a time when I was writing about the strange phenomenon of phantom limbs. I juxtaposed substantial elements of research into this medical enigma with discussion of a select group of contemporary artists, including Heath. Each of the artists demonstrated, to my mind at least, a concern with trauma, absence, touch, and distortion although the ways they manipulated these issues or expressed their ideas bore little correlation to each other. Heath was interesting firstly because he employed the tactile sense in draughtsmanship and painting, and secondly he used a blindfold whilst making drawings (a technique since superseded). Heath's working method was to feel an object with one hand, exploring its surfaces carefully, whilst simultaneously drawing what he felt with the other hand. The process never at any time involved the artist looking at the objects until the work was complete.[1] Heath reflected thus:

There is often a disjunction between the images being shaped on the paper, the way I visualise them and the physical reality of the object itself. The disparity is healthy because it does not confine me to what I imagine, expect or desire to see. There is a need for me to keep my mind open and to frame questions in ways that do not close any doors.[2]

As he anticipated in 1999, Heath has continued to keep his mind open and frame new questions, allowing lines of enquiry to intersect as well as wind their own course. Indeed the drawings in this book are proof of new and distinct developments, which we will come to. What, however, has remained central is 'disjunction', as he called it, between images on paper, his visual perception and the physical appearance of the object drawn. Despite some carefully considered shifts in process, Heath remains an artist fascinated by a magical idea, which we might characterise as "the performance of disjuncture". This idea, which will be developed here, is philosophically resonant but it is just as equally perspicuous, resulting in drawings threaded through with energy and delight which lay themselves open to enjoyment for anyone with an enquiring eye and mind.

This new body of work reiterates Heath's transition from drawing static or solid objects such as sculptures and masks, to drawing ones which, whilst hardly being moving, at least contain elements of organic growth and complexity. Collections of plants in pots (including a money tree, succulents, and orange-blossom) populated Heath's studio at the time and are the subject of all the drawings he made there. Instead of blindfolding himself, as before, and using

touch as the means of gathering primary information about these plants, the artist instead removes the drawing surface or surfaces from his direct sight, though not, of course, out of reach. One method involves putting the sheet of paper beneath a table surface; another is to place the drawing surface to the right or left of the object being drawn, again with the paper out of sight. In a third method he sets up two intersecting freestanding drawing surfaces (which he calls *Four-Fold drawing/four plants*), in which the four resulting quadrants house a plant each. Heath then draws each object using right and left hands, sometimes simultaneously, but on the outermost (and therefore unseen) drawing surfaces.[3] The drawings are never looked at while being made. By using pen and acrylic ink, highly concentrated information is put into the drawing without overloading. As he says, "Before you've looked at the drawing it feels as if there might be everything in the world possible to say about this object in the drawing."[4]

These methods are highly specific strategies where there is an attempt to extract different qualities of information about a perceived form rather than to express or embody an artist's emotional response to a subject. We see automatist swirls and sweeps that intricately criss-cross and fold back on themselves, and disjunctured, colour-coded layers of lines that echo scientific scanning visualisations such as PET (positron emission tomography) and MRI (magnetic resonance imaging).[5] Heath also references architectural tropes – the elevation, plan, and axonometric view. Each strategy has produced drawings of immense delicacy and distinction, perhaps, one might even venture, not quite like any seen before. Heath has the ability (or has created a structure that delivers the ability) to collapse multiple visual impressions into a fibrous ball of intertwined energies. Yet they remain phantoms of the forms they ostensibly represent; firstly in the sense that they have a ghostly yet still recognisable relationship with the object they are based on, and secondly they are born from an absence (that disjuncture between the artist's gaze and the page on which he is drawing). There is, as a result, a purposely unresolved and awkward fusion between that which is real and that which is phantasmagoric.

There is a striking passage in Descartes' *Optics* where the sense of sight is described as analogous to the touch of a blind man's stick. The implication is that we use sight to steer our way in the world and that our optical range projects in a linear fashion from our bodies – the metaphor chiming with more general Enlightenment principles that the human body and its perceptual apparatus are our only

means of knowing the world, and as such mark the limits of empirical truth.[6] It is powerful too, in presenting the senses of sight and touch in fluid neighbourliness – our eyes become tools for feeling the tactile textures of the world. Despite Heath's move from blindfolding himself to removing the drawing paper from his sight – a change which, as he says, means him "using the eyes instead of the fingers to trace the contours of this very complex shape", he is still concerned with substituting sight for touch and rearranging the relationship between the two for himself in the process of working. There is an interesting distinction, however, between the kind of explanation of the world that Descartes was trying to make, and Heath's method, around the location of sensory deprivation. It is as if the stick of Descartes' blind man has been turned behind his back, where it blindly draws unseen representations of the seen world. More precisely, Heath puts blindness not in his eyes but in his hands.

In another part of the *Optics*, Descartes writes of the "two dimensions" of vision, namely a first grouping of location, distance, size and shape, and a second of light and colour.[7] The first group can be confirmed or verified by supplementing sight with touch, but, of course, touch is useless for judging light or colour. On one level, this is familiar neural fact but it also highlights some of the truncations Heath makes in his art, such as between the two dimensions of vision, or the knowledge conveyed by his eyes and his hands.

Heath is explicit here that, with some qualifications, there is an orthodox practice of experimentation going on – "It's setting up a physical experiment about where to drop the paper in relation to these objects", and "it's almost like a spatial problem that one sets". In order to demonstrate or express an idea one must neutralise, sever or isolate the object of experimentation. It is only through isolation that distinctions can be made. Perhaps one of the lasting contributions of Heath's drawing method is to reference quite orthodox or established means of acquiring knowledge but perform them in a way that dissolves any certainty that verifiable information or demonstrably utilitarian knowledge is being formed or imparted. Imparting information might be, and often is, a role for drawing, but not Heath's drawing. The qualifications, alluded to above, relate to this performance pre-empting language and reflection; importantly in this respect Heath points to Goethe's example – "*im Anfang war die Tat!*" ("in the beginning was the deed!").

Heath has described the act of drawing, when he looks hard, moves his eyes around the object, in and out, or even feels detail in the plant surfaces and structures, as a "foreshortening of all these experiences into one flat image". It is Heath's 'performance of disjuncture' with which I started, the very act of drawing in time and space, that allows experience to become foreshortened into images. Perspective, form, detail are each folded into a filmic moment embodied in the drawing; so strongly in fact that we might draw in Henri Bergson, who wrote that "The mechanism of our ordinary knowledge is of a cinematographical kind."[8] This move is much less easily achieved in painting, photography or sculpture, and certainly impossible in text. Consequently, Heath's drawings are surely better considered as performances and not merely as information gathering. For a start, the durational aspect is vital – the extended moment between starting those first strokes on the paper to deciding that the time is ready to look at the results. Bergson realised, right from his early *Time and Free Will*, 1889, that we order sensations in space through the fourth dimension of time. Experience is a fluid state of being where moments cannot be frozen; instead they melt into each other in a private reality of duration. In *Creative Evolution*, 1907, he wrote: "Freedom is the relation of the concrete self to the act which it performs. This relation is indefinable, just because we are free. For we can analyse a thing, but not a process; we can break up extensity, but not duration."[9]

Heath, like Bergson, underlines the importance of 'not knowing during' – what the artist calls "an artificially constructed encounter with an object where I made myself forget as much as possible about it". The truncations, amputations and procedural strategies help to forestall foresight and create the potential for a space of genuine discovery. It is no accident that Heath's drawings do have a quality of automatism, resembling in some ways that of André Masson, for example, but the rationale is different. Heath's 'synthetic' automatism is not a release of unconscious impulses but a self-consciously unselfconscious fusion of perceptual sensations. Even an unobtrusive orange-blossom plant is made, at Heath's invitation, to pass through a dynamic vortex of new possibilities. Contained in the drawing, therefore, are the results of Heath's encounter with the world; the world performing itself in a way we can comprehend but have never before seen.

Andrew Patrizio

1 Two publications on this body of work are Heath, Claude and Taylor, Dorcas, *Drawing from Sculpture*, Leeds: Henry Moore Institute/Leeds City Art Gallery, 1999, and *Atopia: Made Space*, Issue 0.99, 2000, Morrison, Gavin and Stables, Fraser, eds, which features an essay by Chris Noraika.

2 From *Drawing from Sculpture*.

3 Such techniques of either removing objects from sight and attempting to draw them, or removing the drawing itself from sight as you work are actually quite established educational techniques often used with students to free up and challenge their early perceptual habits. Established artists such as Willem de Kooning, Robert Morris and Giuseppe Penone have also made drawings involving self-imposed blindness or a downcast gaze away from the subject. Without the space to elucidate here, it should be noted that Heath's aims are somewhat different and specific to his own intentions.

4 All subsequent quotations from the full transcripts of the interview with Claude Heath are published in this book in shortened form.

5 For comparisons between fine art and contemporary medical visualisation see Stafford, Barbara Maria, *Good Looking. Essays on the Virtue of Images*, Cambridge, MA: MIT Press, 1996, esp. chapter 9, "Medical Ethics as Postmodern Aesthetics", pp. 130-145.

6 Although Descartes is famed for the analogy, it originates in Simplicius Cilicius's commentary on Aristotle's *De Anima*, Venice, 1564. Cited in Jay, Martin, *Downcast Eyes. The Denigration of Vision in Twentieth-Century French Thought*, Berkeley, CA: The University of California Press, 1993, p. 74.

7 Clearly modern neurology and perceptual psychology have advanced the detailed understanding of how different parts of the brain deal with incoming information, and more interestingly ways in which the translations between senses go wrong. See Ramachandran, V S, and Blakeslee, Sandra, *Phantoms in the Brain. Human Nature and the Architecture of the Mind*, London: Fourth Estate, 1998.

8 In *Creative Evolution*, 1907, cited in *Downcast Eyes*, p. 197.

9 *Cited in Downcast Eyes*, p. 197.

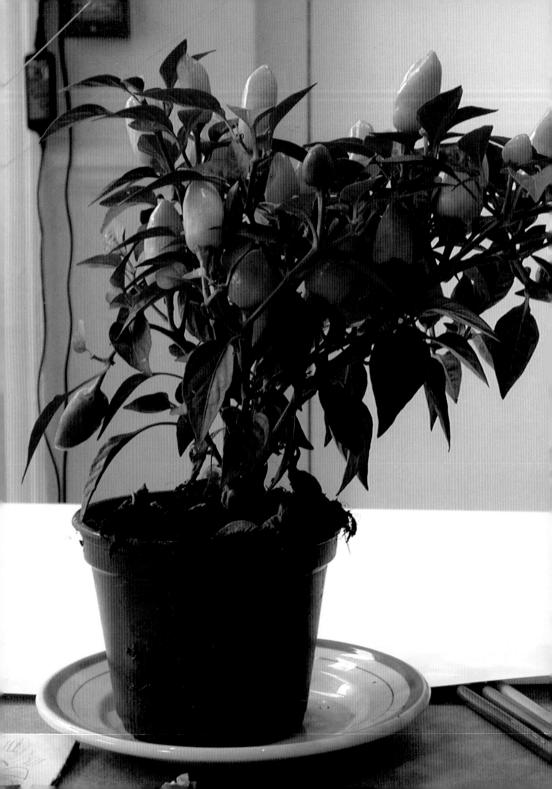

WHEN YOU FOLLOW THE MOVEMENTS OF A FOOTBALL
ACROSS A FLAT TV SCREEN YOU SOMETIMES HAVE THE
SENSATION THAT THE BALL IS GOING IN A CERTAIN
DIRECTION WHEN IT TURNS OUT TO HAVE A DIFFERENT
ARC ALTOGETHER AND ENDS UP AT THE FEET OF A
DIFFERENT PLAYER THAN YOU HAD FIRST THOUGHT.
ITS TRUE MOVEMENTS ARE HIDDEN BY THE FLATNESS
OF THE SCREEN UNTIL IT ARRIVES AT SOME PARTICULAR
PART OF THE PITCH. THIS SAME KIND OF SENSATION
SOMETIMES HAPPENS WHILE DRAWING, WHEN YOU
ATTEMPT TO COMPRESS THE SIGHT AND TOUCH OF A
SOLID OBJECT ONTO VARIOUS PARTS OF A FLAT SURFACE.
I WANT TO LOOK FURTHER INTO THIS.

WORKING FROM PLANTS NOW, IT WILL ALSO BE
INTERESTING TO SEE WHETHER IT IS POSSIBLE TO SET
THEM DOWN JUST AS THEY ARE, BUT AS IF RENDERED
BY A THREE-DIMENSIONAL COMPUTER PROGRAMME
THAT HAS TAKEN A HOLIDAY FROM MATHEMATICS.

Claude Heath, October 2001

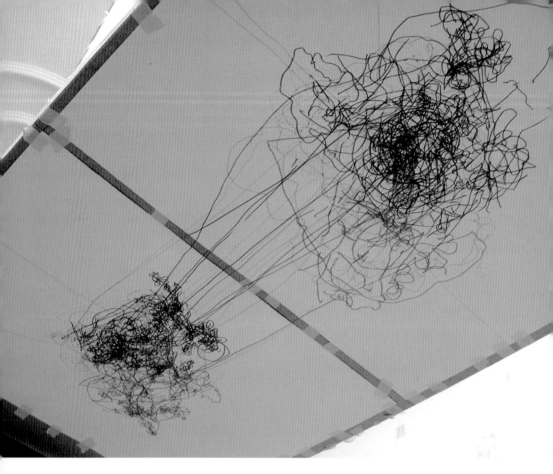

Drawings of
Sedum burrito
and money plant
under work table

**Four-Fold Drawing /
Four Plants**

acrylic ink on paper,
mounted on board, 2001,
29.5 x 84.5 x 84.5 cm

(and on following pages)

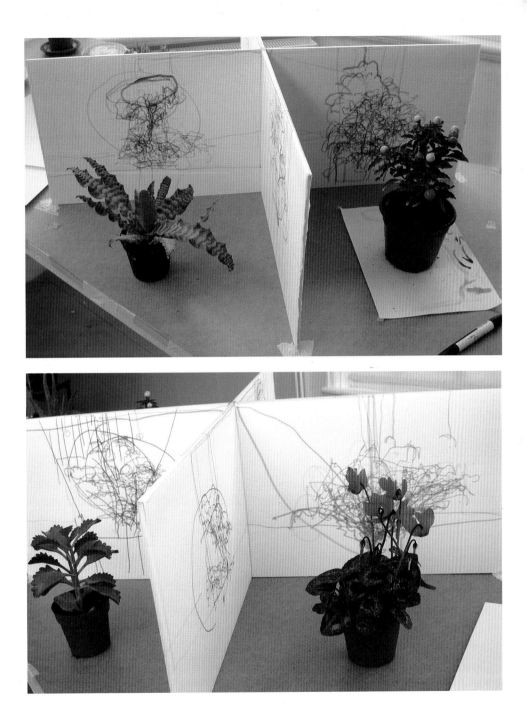

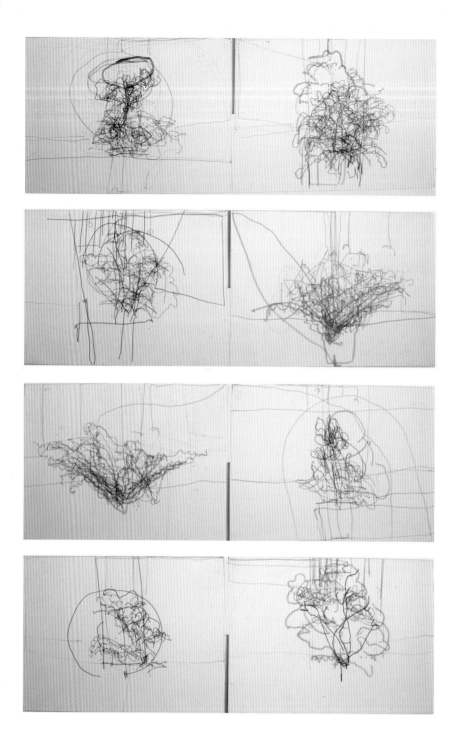

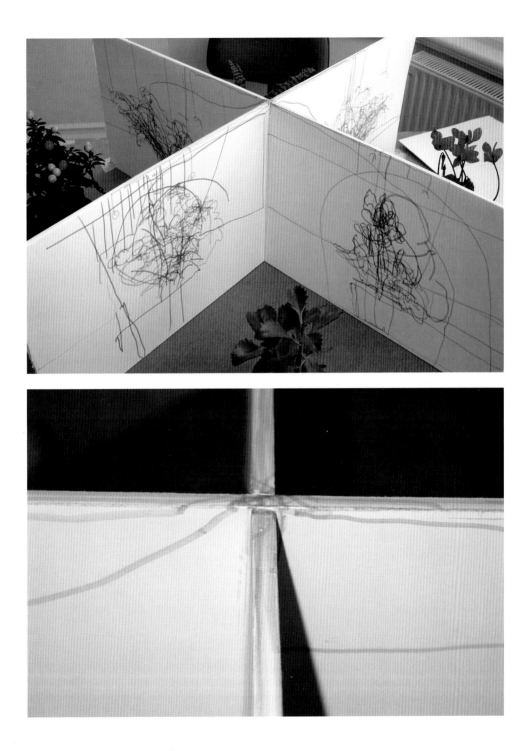

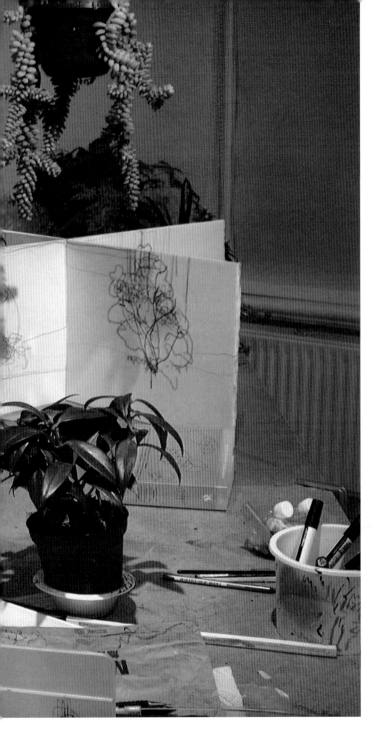

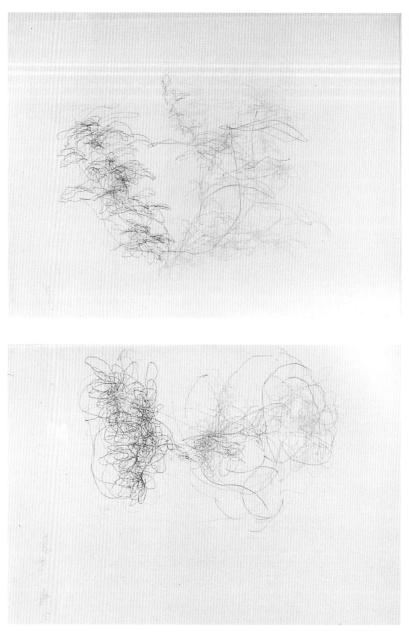

Left: **Mexican Orange Blossom (Choisya ternata), 5.10.01**

all two-part drawings: pencil or acrylic ink on paper, 2001, 56 x 76 cm each sheet unframed, 128 x 88 cm framed, except where indicated

Right: **Money Plant and Artemesia, 10.01**

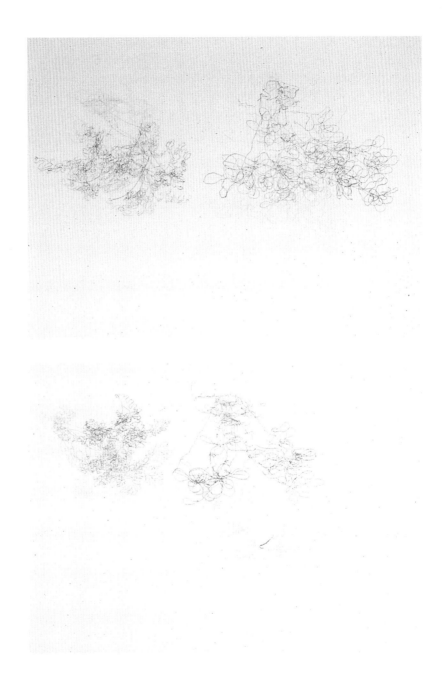

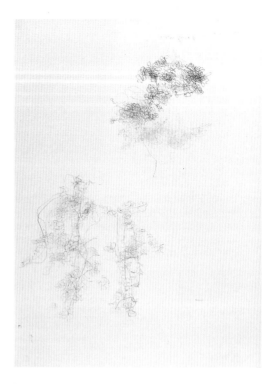

Above: **Sedum burrito,
8.10.01**

76 x 56 cm each sheet
unframed, 88 x 128 cm
framed

Right: **Mexican Orange
Blossom (Choisya
ternata), 1.10.01**

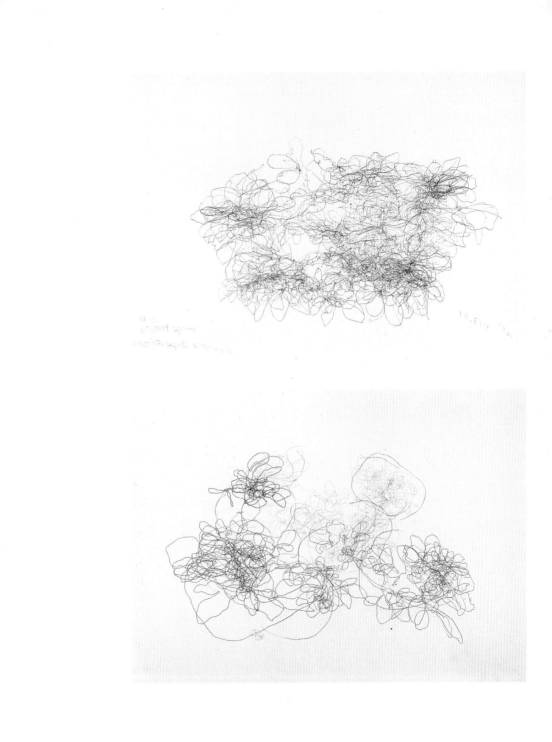

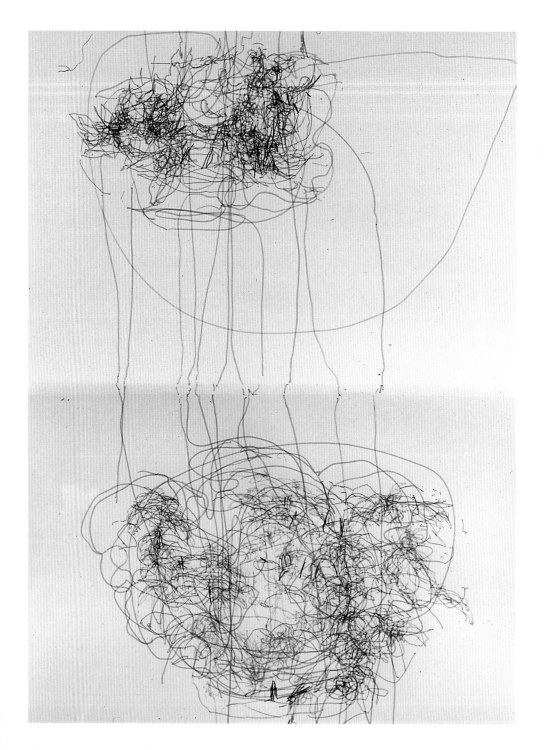

What is drawing? Claude Heath

Left: **One Fold Drawing /
Two Plants**, 10.01

acrylic ink on paper,
76 x 112 cm

Below: **Money Plant**,
10.01

Overleaf, left: **Sedum
Burrito**, 18.10.01

Overleaf, right: **Mexican
Orange Blossom**,
22.10.01

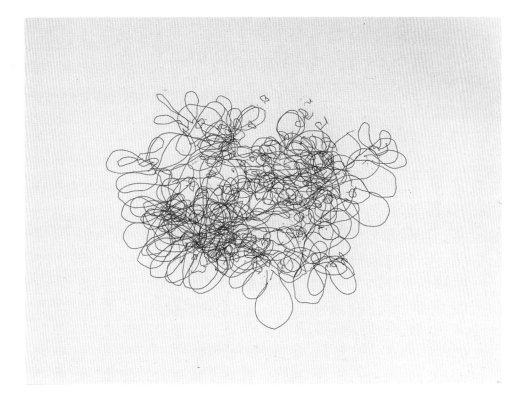

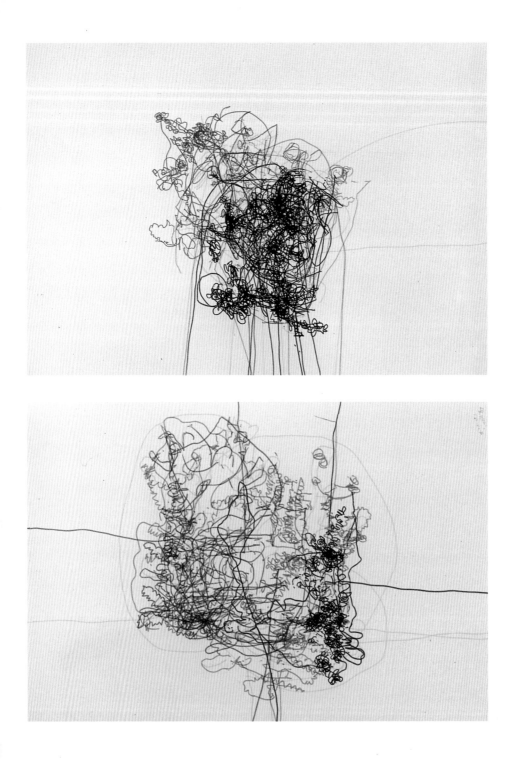

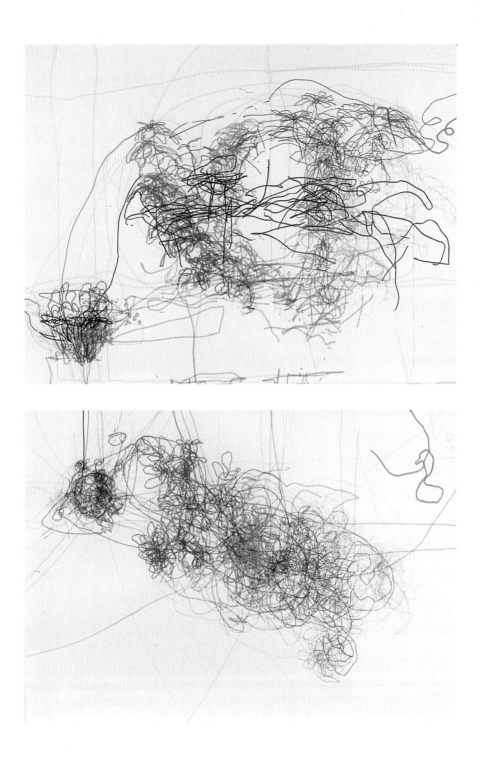

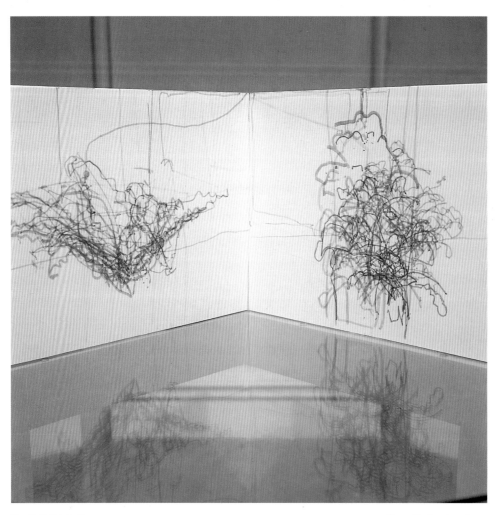

**Four-Fold Drawing/
Four-Plants**

as exhibited,
November–December 2001

acrylic ink on paper,
mounted on board, 2001,
29.5 x 84.5 x 84.5 cm

Above: **Choisya ternata**

acrylic on linen, 2002,
122 x 91.5 cm

Below: **Sedum burrito**

acrylic on canvas, 2002,
107 x 107 cm

collection of Martin Holman

(and on following pages)

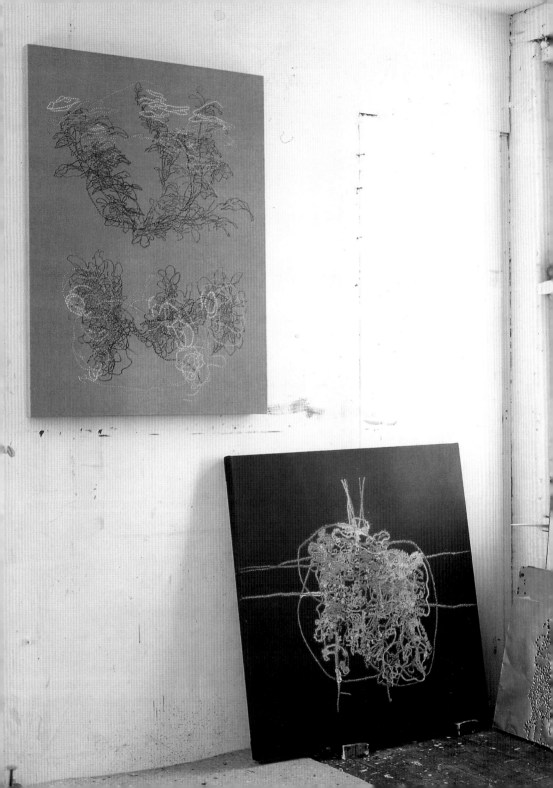

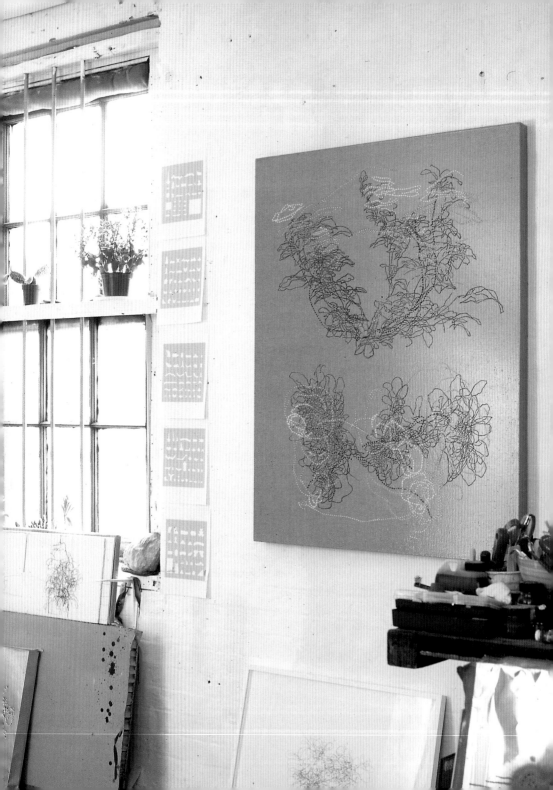

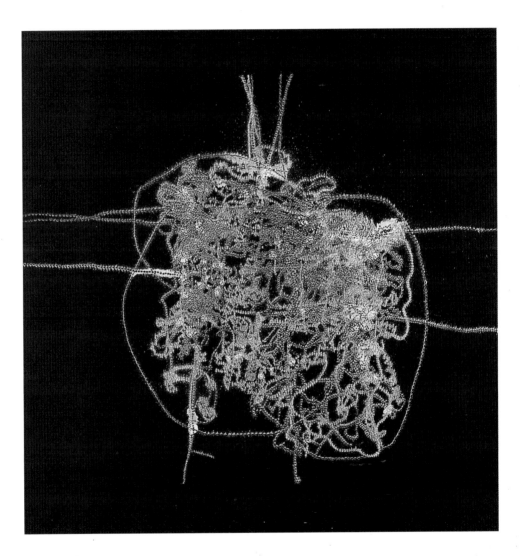

Claude Heath was born in London in 1964 and studied Philosophy at King's College, London (1983-1986). He lives and works in London.

He had his first solo exhibition in London in 1995 at Hales Gallery. In 1996 he was included in *Young British Artists VI* at the Saatchi Gallery, London and *The Whitechapel Open* at Whitechapel Art Gallery, London. More recently, he has exhibited at De Appel Foundation, Amsterdam and in *The John Moores Exhibition 20* (as a prize-winner), Walker Art Gallery, Liverpool, 1997; in *The Whitechapel Open* and in *Antechamber* at the Whitechapel Art Gallery, London and in *The Jerwood Painting Prize* at the Jerwood Space, London, 1998; in *The John Moores Exhibition 21*, Walker Art Gallery, Liverpool, in *The Natwest Art Prize*, at Lothbury, London, at Nicole Klagsbrun Gallery, New York, and at the Henry Moore Institute/ Leeds City Art Gallery, 1999; in *Art in Sacred Spaces*, a Millenium Fund commission and school residency at Christchurch, Isle of Dogs, London, 2000; at Paul Kasmin Gallery, New York, at the British Museum, London, and at Essor Gallery, London, 2001; and at Kettle's Yard Gallery, Cambridge, 2002.

Heath was the first artist in residence at the Henry Moore Institute and this led to his solo exhibition at Leeds City Art Gallery. He is the 2002-2003 Kettle's Yard Artist Fellow at Christ's College, Cambridge.

His work is included in a number of collections, including the Arts Council Collection at the Hayward Gallery, The British Museum, Deutsche Bank, the Henry Moore Institute and the Walker Art Gallery.

Claude Heath is represented by Paul Kasmin Gallery, New York.

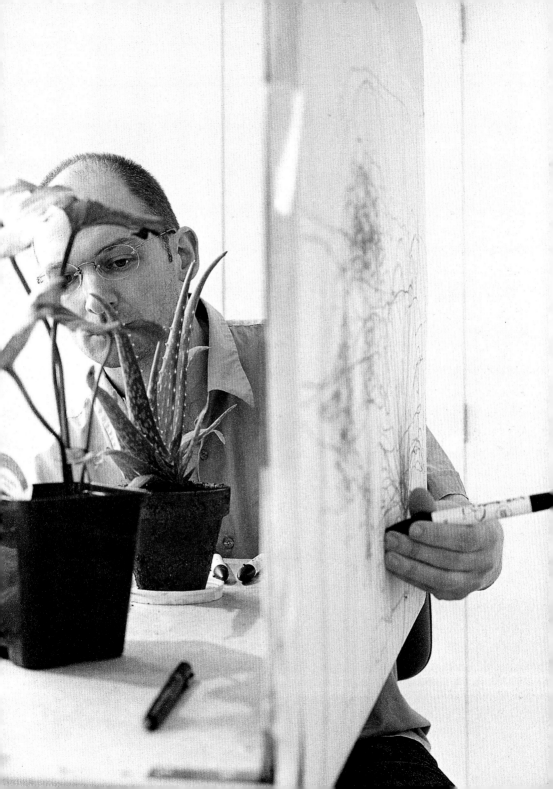

Lucy Gunning in conversation

Michael Ginsborg: You wrote something about drawing which I thought was very good. You mentioned drawing's fluidity and tentativeness; that there were parallels between drawing and filming, and how, whether one was recording something with a camera or a pencil, there was the same potential for something new to be created. I agree with so much of what you say about drawing – especially about creating a new thing. I think that drawing can do this because its means are so completely bounded rather than open to anything. And I would go as far as saying that I think it is basically a monochromatic medium, and that its support is paper, and so on. I really like your show and I have no difficulty with your definition of drawing; I think what you've done here needed to happen, in a strange way. But there are two views and obviously your view, or your experience, your actions, represent a completely different approach to drawing from my own. How did you approach this residency?

Lucy Gunning: In practical terms I did start off drawing, literally drawing with pencil and paper, to remind myself of what drawing was to me.

MG: I wondered whether you arrived with a plan?

LG: I wanted to keep it as open as possible. I tend to work intuitively – to see what will come up. But looking back at the experience, there are things that I brought with me and certain things that have happened precisely as a response to being in the space. I reached a point where I went with what was happening, rather than thinking about the written definition of drawing I had come up with.

MG: Though some of the things that you wrote about are quite evident in the show.

LG: I imagined that I would show what I had filmed, which I haven't. I started off by drawing, then taking photographs. Taking photographs became quite a natural medium for me to work with in this context.

MG: You were talking to me about the fact that when filming, there's a certain stage at which a film goes away from you in the editing: you lose contact. What did you mean by that – do you mean when that immediate closeness is lost?

LG: There comes a point where you have to step outside of it and be objective in order to deal with it as material.

MG: This show didn't strike me as objective at all. In fact, in some of the earlier videos, such as *The Singing Lesson*, the subject is you. The subject of your video works always seems to be you, in a sense, even when someone else is performing. In this particular exhibition, the subject is absolutely, specifically, defined as you.

LG: I have used my experience here as an opportunity to put myself back into the work. I was ready to do that and there's also something about the experience of working in a room and having a studio practice, which I don't always have. So I became another material, like the dress that I used, like the blanket, like the person in the films.

MG: Each photograph or part of the show, starting from the division of the room into two halves, gives

a great deal to the viewer to invent: a possible narrative, and even a certain kind of symbolising of things. In the front part, there's a small drawing of the back of the room, a drawing over a photocopy of an imagined audience. Like all the things in the show, it is the only one of its kind. There aren't ten of them, there are not ten of anything in the show – though there is that sequence of photos. The image of the audience really interested me. There's clearly a theatrical aspect, the blankets being the curtains you come through and curtsey and bow in one of the series of photographs. What was in your mind when you were drawing that audience?

LG: That drawing came about because I was spending a lot of time in the room, which is essentially a domestic space which has been turned into a gallery/studio space. I was reminded of an idea for a piece of work that I'd had – around the time that I made *Climbing Around my Room* – where I had wanted to see how many people I could get into my room. I never made that piece. I thought about making it here, and that drawing was a reminder of it. I took a photograph from outside of the room, looking in through the window: a very particular view of the room, slightly from above. That was the photograph I photocopied and then drew on. But I like the connection that you make between the drawing and an audience, which I hadn't thought about directly. It's something that I have come back to over and over again. I remember doing a seminar when I was at Goldsmiths. I made the audience take an item of clothing from a bag as they came in the door, so they all had to wear something slightly foreign to them as they came in. This played with the relationship between the performer and the audience, who was actually performing and who was the audience.

MG: There is a pathos in this predicament of self-observation and an implied but absent audience. Another way I was thinking about the experience was: you enter this room, and you, Lucy Gunning, are not there; but everything is the result of what you did when you *were* there. I feel that you are drawing attention to your own absence.

LG: I am, but I want those things to be things in themselves that relate to each other independently. I don't want it just to be: "These are the remnants of what I did." I hope something else happens too.

MG: Of course it does. Maybe my reaction is a result of the way the residency and the exhibition occur in the same space. You *know* you're in the space where Lucy Gunning was, in that white dress. There's an awareness of the absence of the artist which is particular.

LG: That's true and it's something I have played with before. I took a series of photographs of a situation. In one photograph I'd be in it and then in the next one I wouldn't.

MG: I thought the exhibition includes terrifically honest and poignant works. A number of things stand out. One of the pieces that wasn't done in the room – I am sure it wasn't – is the one where you're dancing. It's a kind of "I am the only guest at my party" kind of picture. Dancing on one's own, in a room with the remnants of an attempt to make some kind of jollification happen. Another

piece of work that a lot of people have identified with was the one where you've stuck a cat's tail on and you're climbing out the window. That's what we all want to do desperately sometimes; to escape. The artist has worked, has bowed and curtsied, and can't stand this for another moment and just has to escape. I felt that you were setting up a lot of these psychological responses.

LG: I definitely was. Though a lot of them emerged just from playing around with certain props. I don't know if it's my role to provide psychological readings, my reasons for climbing out the window or putting a tail on. Part of the beauty of being here for six weeks has been that I don't normally show or work in that kind of space. Also, coming back to what I said earlier about putting myself back into the work, and thinking precisely what this situation here is: it's a residency and a *drawing* residency, so it felt appropriate to explore these things as beginnings and let them have more importance than they have had in the past.

MG: We talked about this earlier: that there may be very few actual drawings in my sense of the word in the show, but the whole show embodies an attitude which is a drawing attitude. When you talk of the beginnings of things, that's something that drawing is well known for: being able to contain or give material expression to beginnings. I certainly think that is happening. Can I ask you – it's a vexed question that is often asked around drawing – about the question of skill. Where do you think skill comes in to what you do?

LG: Um… I suppose my answer to that is I think mistakes are really important. And – well, I suppose it *is* something I think quite a lot about. In works such as *The Singing Lesson*, it's precisely skill or lack of skill that has really interested me. I had never taken so many photographs in such a short period of time before as I have here. Certain things I would want to happen and then others would happen by accident, or without me realising they were going to. Then I would try to make things happen again, or not, and so it was a learning process, which is something that is important in my work. If I am not being surprised by it, then it's not happening.

Question from the audience: This point about surprise: what tends to be understood by this is that you mean a good surprise. But if it's an unpleasant one, then you've got a problem. But there also seems to be a kind of anxiety in your work, an uncertainty of production in the whole set-up.

LG: An uncertainty?

Questioner: Yes, and the whole situation that gave rise to this work is one in which a certain kind of product wasn't envisaged. Whereas so much of the way work is framed now is in terms of the success of outputs or exhibitions. It seems to me that there is a really important part of work, a kind of dark side of it, which is not always given expression. How do you negotiate this other part of making work, the uncertainties of it? Because there is a tentativeness that seems to be in the work, and I would call it anxiety too.

LG: I think I have a love-hate relationship with being in the situation of not knowing. But it is also what excites me. I do really understand what you said about your experience of showing, that it often doesn't allow for uncertainty, whereas this situation here has. All I can say is that after about the first three weeks the situation turned around and I actually felt much more comfortable with not knowing what was going to happen. The work called *Blankets*, I did on Sunday. If someone had told me I would still be making work on Sunday, when the opening was on Wednesday, then I would think "Forget it! That's impossible!" But this situation has allowed for that.

MG: And one of the real problems with words like spontaneity is how we take them for granted. When you say something like "the dark side" or, as we say so often, "it's good to be lost" – to not know where you're going – they're real states. If we take them seriously they could actually mean something destructive; they might mean the end of making. When I said to you that, in one of the sequences of photos, "You're having a real go at this figure" you said "Yes, it's my monster." I thought that was very illuminating, as a response. Because it almost looks like a medieval Zen Buddhist monk.

Member of the audience: Following on from the discussion, I was reminded of when Hélène Cixous writes about drawing. She talks about the state of 'drawing-ness'; the state of leading up to, of not being art; the point at which drawings are executed. I call this the 'fall-out' of the making, that sense of when you are treading a very fine line between it being art and it being 'not-art'.

LG: I haven't read anything she's written about drawing in particular. I have read a lot of her work and I'm really interested in it, especially her understanding of a way of being in the present moment.

Member of the audience: She talks about what escapes the drawing, which reminds me very much of what I have seen of your work. She talks about the triangular relationship between the drawing, the artist and the beholder and what happens between – in – that triangle. And that sense of writing around something that is almost trying to escape. As far as I gather, it's what she sees as the essential thing about drawing. Perhaps the pathos Michael was describing earlier is to do with that.

Member of the audience: I just wanted to ask about your work's strong connection with performance. There is a strong feeling I always get with viewing your work, of being a person drawn through its particular space. I am thinking about the installation you made at Matt's Gallery with the monitors on which people were speaking and stuttering, which would then cut out. That drew you through the space. Then with the most recent work, *Intermediate II*, you're drawn through that space in a particular way, view it in a particular way and you move into the other space, the mirrored room. In the exhibition here, with the megaphone and the mirror, you are very aware of being in some kind of performance space.

LG: The residency has made me observe my practice in a different way. Partly because students have come in once a week, and I have been able to see where I am up to and how I have used the space. At the beginning I thought I was going to bring a lot of things in. I did the complete opposite. I just waited. The first thing I brought in was a white dress,

which you could hardly see because the walls are white. And what then also started to happen, slowly, was that I realised I was using one part of the space as a space for thinking and writing and reflecting and another part of the space became a space that I performed in – or put things in. It became much more obvious that there were two things going on. I knew that I wanted to bring in the blankets beforehand. I didn't know that I was going to separate the room into two parts. I don't know if that answers your question...

Member of the audience: It does because you are also talking about that space where you're actually making decisions, within a space which seems to be a starting point. I am just thinking of when you put an advert in a newsletter asking stutterers if they would like to take part in the work made for Matt's – how you were thinking of voices, about how people communicate and about your own hesitant voice. For that work there was also a material beginning. You started gathering together objects – monitors – and started to think about how they might be arranged. Different spaces have very much focused your work in different ways.

LG: It's something that's always there: even when I have shown a single-screen monitor piece, I have a particular away of putting it in the space. The physical space is important.

Member of the audience: Obviously the show you've made here relates to past works, or will be seen in relation to them – so the white dress perhaps recalls the red dress of *Climbing Around my Room*. What about the connection forward? When you talk about these works as 'the beginnings', do you anticipate works coming from them?

LG: I don't know. Probably yes. But, I tend to let things sit over here somewhere [hand gesture to one side] rather than staring them in the face and going for them in that way. I have to live with them a bit first.

Member of the audience: If it does turn out that you make other works from them, then they absolutely fit a very conventional definition of drawing.

LG: Yes.

Member of the audience: In a way we were interested in you doing a residency after Claude Heath, who is quite a traditionalist in the way that drawing generates imagery for painting. And we do hope to revisit artists to find out the consequences.

LG: Like one of those TV programmes where they come and see what you're doing in thirty years' time! Though for me the destination is the journey. I make work and shows pick up on where the work is at that moment in time, so they're sort of offshoots – or a situation where you have to rise to a certain occasion, I suppose. Time creates the endpoint.

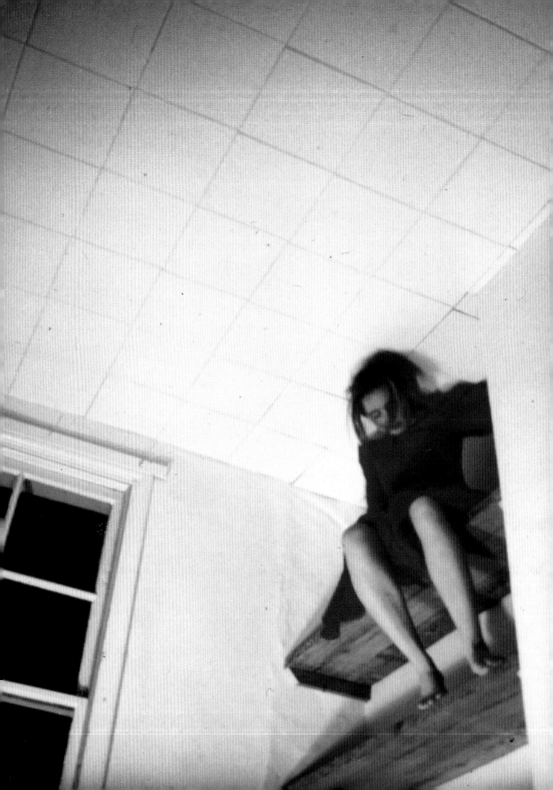

**Climbing Around
my Room**

(location shot),
7.5 min VHS, 1993

The Footballers

(video still),
30 min VHS, 1994

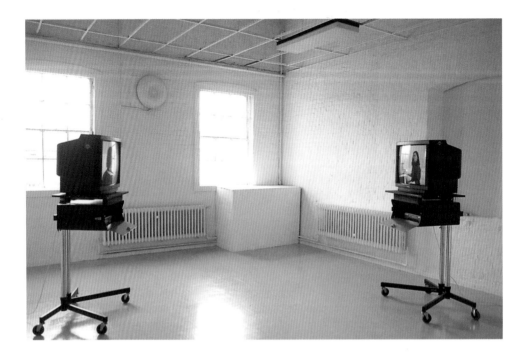

The Singing Lesson

(installation shot and
video stills), two 27"
monitors, each with 60 min
VHS, 1994, Goldsmiths
College, London

Malcolm, Lloyd, Angela, Norman and Jane

(installation shot and
video stills), five monitors,
two tables, dimensions
variable, 1998,
GreeneNaftali Gallery

photo: courtesy of the
artist and GreeneNaftali
Gallery

Intermediate II

(video still and installation
shots), 2001,
4.50 x 3.35 m ballet
studio, other dimensions
variable, Tate Britain,
London and GreeneNaftali
Gallery, New York

photos: courtesy of the
artist, GreeneNaftali
Gallery and Tate Britain

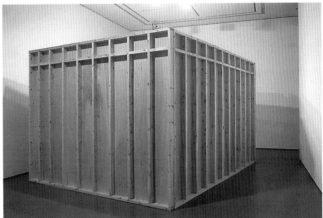

Lucy Gunning: Wearing flowers, drawing flowers, looking at flowers[1]

It all started with an almost empty and silent room, in a house now transformed into a studio/gallery. The room has windows overlooking the street and the courtyard outside, yet it is an enclosed and quiet shelter. In its function it points towards the adjacent art school, but it also represents an escape from working routines and habitual pressures. Despite its lack of furniture and other decorations common to a domestic environment, this room seems to maintain in its shape and its features the intimate appeal of the original living space.

In a room of this kind, reminiscent of the bare domestic interior where she filmed her first and best known video work, *Climbing Around my Room*, Lucy Gunning was invited to spend a period of six weeks exploring the practice and act of drawing. Although her work has most often taken the form of video or of installations incorporating video, drawing is still part of her practice. Sketches she realises from time to time can become the starting point for further articulating her installations. Her drawings more often constitute preparatory studies, as Vasari would describe them:

> Sketches... are made in the form of a blotch, and are put down by us only as a rough draft of the whole. Out of the artist's impetuous mood they are hastily thrown off, with pen or other drawing instrument or with charcoal, only to test the spirit of that which occurs to him...[2]

When she was invited to occupy the room described above, and she started "reconsidering drawing in relation to her practice", it was as if "the spirit of that which occurs to her" was to be reflected upon.[3] Through the magnifying lens of this artform, a particular focus on her own perceptions and their traces in the receptacle of her temporary studio was to emerge. If it is true that the intertwining relationships between the artworks, the gallery space and the onlooker's viewpoint are at the core of most of her works, on this occasion Gunning's more overt participation in such dialogues constitutes an additional and enticing element, and one that can be explored.

In the practice of this artist the unpredictable flow of everyday processes is re-staged and metaphorically re-drawn in sometimes complex unfolding exercises. From *Climbing Around my Room* up to *Intermediate II*, Gunning's practice explores anomalous and dislocated moments where our common and passive perceptions are interrupted, and an alternative route is then suggested to our senses. Behind and beyond our composed behaviour (as in *The Horse*

Impressionists), our functional language (as in *Malcolm, Lloyd, Angela, Norman, Jane*, made with the help of speech-impaired subjects), and more generally the regular surface of things as informative 'signs', Gunning's work has found ways in which the unconscious and unexploited energies of our daily pursuits can be brought to the surface through the camera, which traces their uncanny shapes and idiosyncratic modes. In this respect the motions of the camera are not much different from that of a pencil:

> I am interested in parallels between drawing and filming; hand-held fluidity, the camera drawing in information. How recording something with a pencil or a camera isn't so much a way of capturing an existing thing as creating a new one.[4]

In the enclosure formed by the bare walls of the studio/gallery, the 'existing thing', the starting point, is the physical and psychological presence of the artist, which is registered by the 'tracing' activity of the camera's gaze, in this instance through still photographs, some arranged in sequences. It is in part the space between the artist as actor and the artist as viewer that is investigated. A close attention to the open and unpredictable relationship between the artist's body and its surroundings gives rise to an experience for the viewer of co-performing the work. This use of still photography means that connections can be traced between performance and self-portrait, self-portrait and still life, still life and installation.

At the beginning of the six weeks, Gunning brought a white dress into the room, hung it on the wall, and drew it. As stated by Dani Cavallaro and Alexandra Warwick,

> Dress... is a manifestation of the unconscious at work, in that it is a superficial phenomenon, like symbolic language, which, also like language, speaks volumes about submerged dimensions of experience. Clothing, then, does not just operate as a disguising or concealing strategy. In fact, it could be regarded as a deep surface, a manifestation of the 'unconscious', as a facet of existence which cannot be relegated to the psyche's innermost hidden depths but actually expresses itself through apparently superficial activities.[5]

The white dress, in this respect, not only suggests a wish to both camouflage and reveal itself against the white walls (therefore being both present and absent), but also hints at an elaborate relationship between surface and depth.

On one level the dress adopted has a history, as it appeared in a previous video piece by the artist, *The Footballers*. Similarly, a past with its layers and its shadows resonated within the white walls of the room against which the dress was positioned. Both object and space, despite their pure and untouched appearance, proved to have a depth behind and beyond their neutral flatness, a hidden life to retrieve and retrace, made of their past and present possibilities. The white outfit struck a bizarre balance between its abstract appeal and the functionality of its cut. It became susceptible to a number of repositioning gestures: first located on the wall where one would expect a two-dimensional drawing to be, then redrawn as a static three-dimensional object; then the drawing itself was photocopied, then again the object/outfit was photographed, and finally worn by the artist.

It is with the appearance of the white flowers that the two-way passage from object to subject, from still life to self-portrait comes to light. It is witnessed through three photographs, one showing the artist from behind while she draws the flowers, another presenting the flowers in a more typical still life, and a third one shifting to a more obvious self-portrait where the artist is depicted with flowers in her hair.

The concept of self-portraiture is an underlying concern, even if the presence of the artist in the process and in the photographs was mercurial. During the residency a mirror was taped to the wall, at an oblique angle. Whilst the mirror's awkward and altogether functional position created a dialogue between the surface and depth of the mirrored space, some more tape on the floor indicated not only where the artist once stood, but also where the viewer could potentially stand to produce a self-portrait.

It seems appropriate to say that the artist playfully positions herself not only in between artistic genres but also in between participation and distance. An escape from the room was attempted: a large photograph shows Gunning climbing out of the window, dressed up in her white outfit and with a tail. In the same way the portrayed artist seems to stand between the conscious and the unconscious, the tail sensually operating as an instinctive directional tool.

Within the accumulative interplay of drawing, performance, and photography, a parallel between the repetition and re-presentation of something is key. The concept of repetition has already appeared in other works by Gunning, where mimicry transforms the sound of the voice,

as in *The Singing Lesson* and in *The Horse Impressionists*, or is reflected onto viewers through the presence of mirrors, as in the ballet school room of *Intermediate II*. Generally in her works repetition implies disconnection or absence, bringing about something reminiscent of an impression, a trace of the unconscious, a fragmented and disrupted version rather than the perfect fixed copy of a unique, stable, and immutable object.[6]

The repetition of the same subject, or the same act, is intersected by its presentation as an image. Such dynamics highlight the role of the gaze in Gunning's works. In her exhibition, the effect was enhanced by the dialogue performed between objects and unframed photos. The images selected and accurately positioned in relation to the space did not function as documentation or as residues of a performance: in their conversation with the objects and the actions performed they maintained a specific status and viewpoint. A long series of snapshot-sized pictures, collectively titled *Blankets*, presented a narrative which included most of the objects brought in to the room, which the viewer found within the space: the white dress, pink blankets, a ladder, photographic lamps. This narrative, however, was loosely traced: a provisional theatrical setting had been put up and taken down again, the 'curtains' being used, in the meantime, to suggest another figure which became part of the story. Transformations not only applied to the space, which fluctuated between stage, working and living space, and void, but also to the artist, who spent time and performed there in different roles. Boundaries, such as the one defining the artist's staging space from the viewer's observatory space, were constantly crossed. This gave the impression that the artist was (and in a sense continued to be) both on stage and outside it, with the viewer feeling both removed from the performance and repositioned in the middle of it.

If it all started in an almost empty and silent room, the end is the most difficult part to trace. In fact maybe there was or is no end, but only an ongoing transformation of signs and traces, experiences, positions, boundaries between here and there, now and then.

Irene Amore

1 This is the title of a work by Lucy Gunning, illustrated on p. 76.

2 Vasari, *On Technique*, Louisa S Maclehose, trans, New York: Dover Publications, 1960, p. 212.

3 Artist's statement, p. 77.

4 Artist's statement, p. 77.

5 Cavallaro, Dani and Alexandra Warwick, eds, *Fashioning the Frame: Boundaries, Dress and Body*, New York: Oxford University Press, 1998, p. xxiii.

6 Referring to Deleuze's *Difference and Repetition*, and applying some of Deleuze's notions to the context of performance art, Anthony Howell noted that: "Representation is a conscious repetition, motivated by desire.... It is carried out with a conscious purpose perhaps to disguise ourselves as our enemy, perhaps to depict something we wish to retain and examine.... Repetition, on the other hand, is often unconscious... so we repress why we repeat – or so it seems. In its non-representational, repetitive mode, performance art is an art of the unconscious... Deleuze considers repetition to be the unconscious of representation. He speaks of 'an inverse relation between repetition and consciousness, repetition and remembering, repetition and recognition...'." See Howell, A, *The Analysis of Performance Art*, Amsterdam: Harwood Academic Publishers, 1999, pp. 30-31.

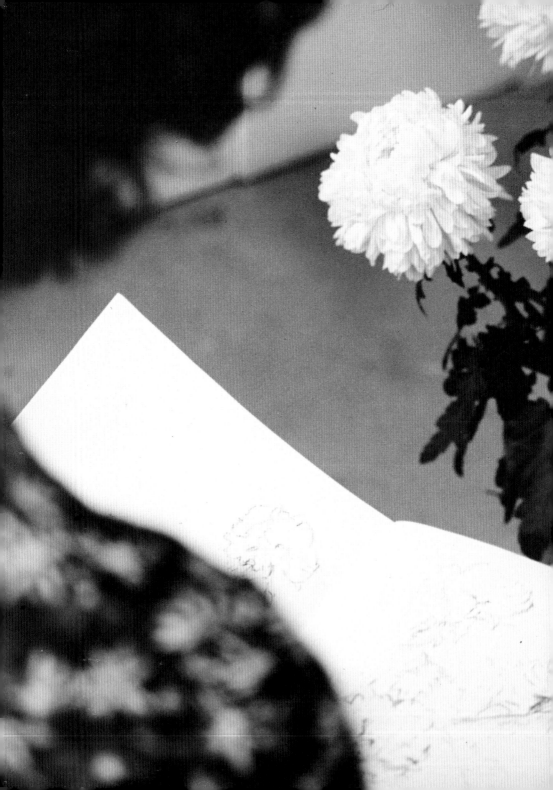

THIS IS A TIME FOR ME TO RECONSIDER DRAWING
IN RELATION TO MY PRACTICE. 'DRAWING' FOR ME
EMBODIES A PARTICULAR APPROACH TO WORKING,
AN IMMEDIACY, A FLUIDITY AND A TENTATIVENESS THAT
I ENJOY — A MOVEMENT TOWARDS AN END AND THEN
A MOVEMENT BACK FROM THERE, SO THAT IT REMAINS
AN APPROACH RATHER THAN A HIGHLY POLISHED,
FINISHED THING. I AM INTERESTED IN PARALLELS
BETWEEN DRAWING AND FILMING; HAND-HELD FLUIDITY,
THE CAMERA DRAWING IN INFORMATION THAT IS
ALREADY FRAMED AND EDITED. HOW RECORDING
SOMETHING WITH A PENCIL OR A CAMERA ISN'T SO
MUCH A WAY OF CAPTURING AN EXISTING THING AS
CREATING A NEW ONE.

Lucy Gunning, January 2002

Wearing Flowers,
Drawing Flowers,
Looking at Flowers
photograph, 2002,
40 x 54 cm

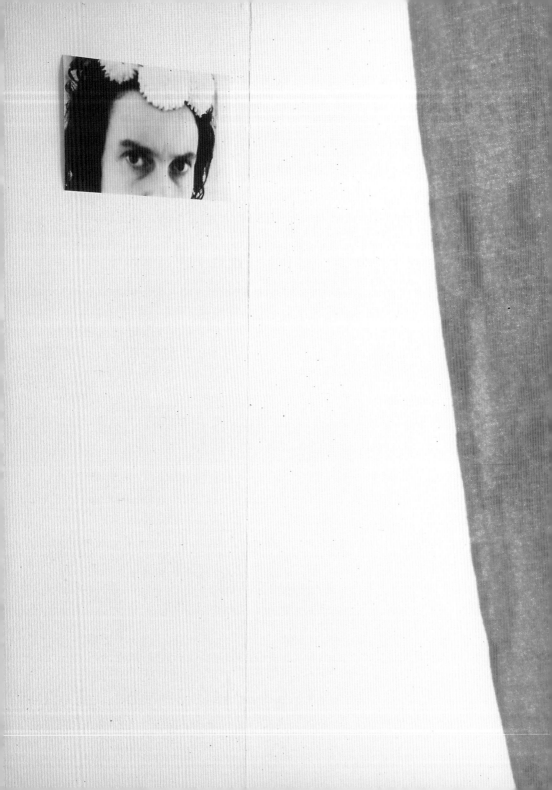

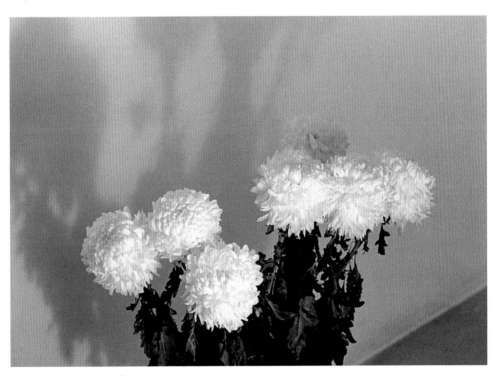

Flowers in Hair
installation view
photograph, 2002,
16.5 x 25.5 cm

Flowers
photograph, 2002,
30.5 x 40.5 cm

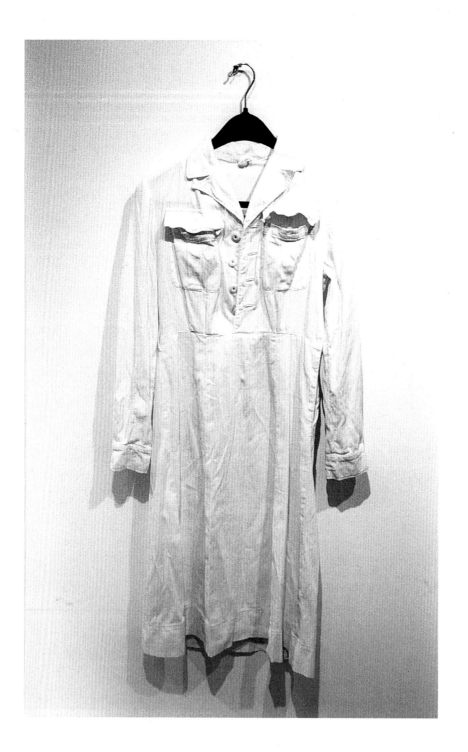

Dress

photograph, 2002,
25.5 x 16.5 cm

Dress

colour photocopy, 2002,
29.5 x 20.5 cm

**Filling the Room
with People**

black ink on colour
photocopy, 2002,
30 x 42 cm

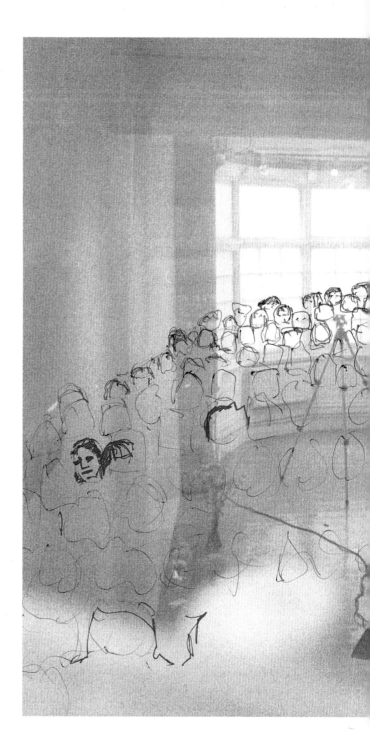

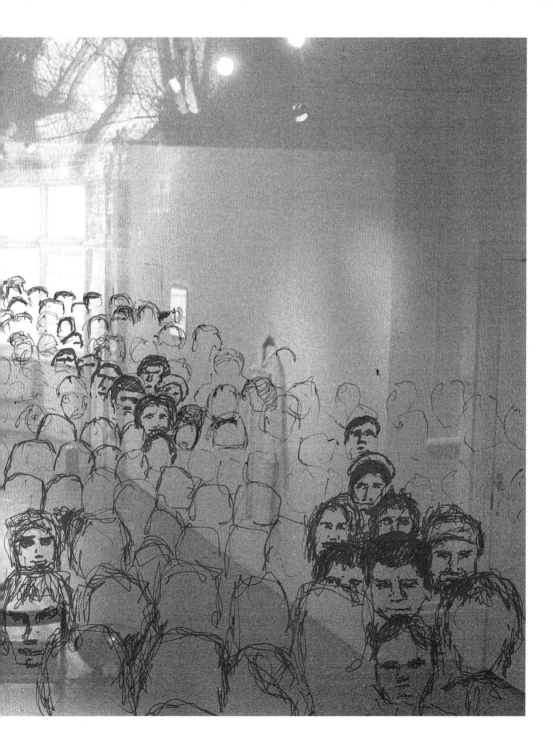

Room as a Phallus

composite photographs,
2002, 16 x 34
and 15 x 30 cm

Triptych

three 'Snappy Snap'
photographs, 2002,
each 15 x 10 cm

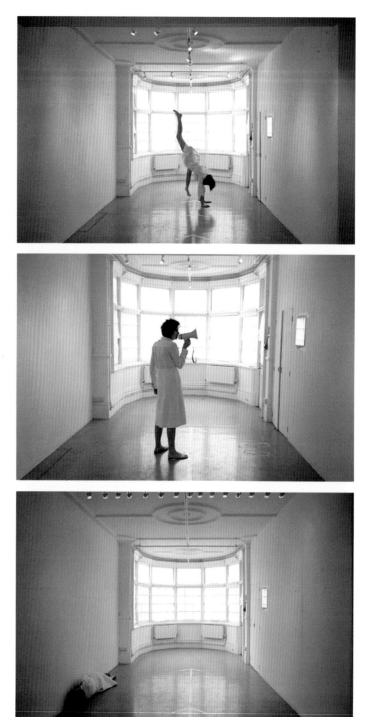

What is drawing? Lucy Gunning

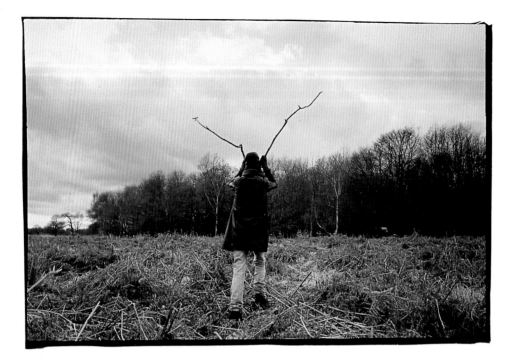

Deer

photograph, 2002,
84 x 126 cm

Dancing

photograph, 2002,
69 x 101 cm

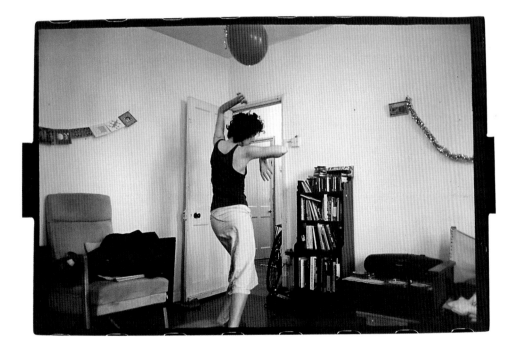

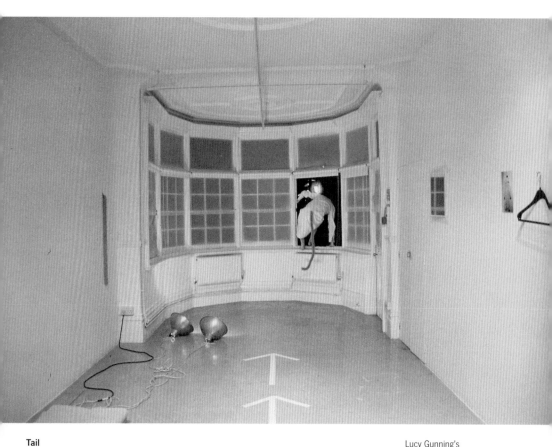

Tail

photograph,
2002, 51 x 61 cm

Lucy Gunning's
exhibition, March 2002

(and on following pages)

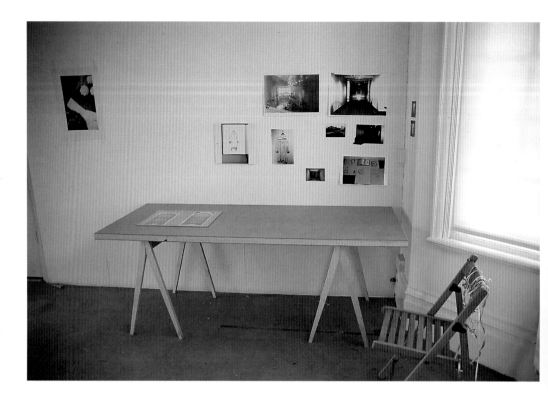

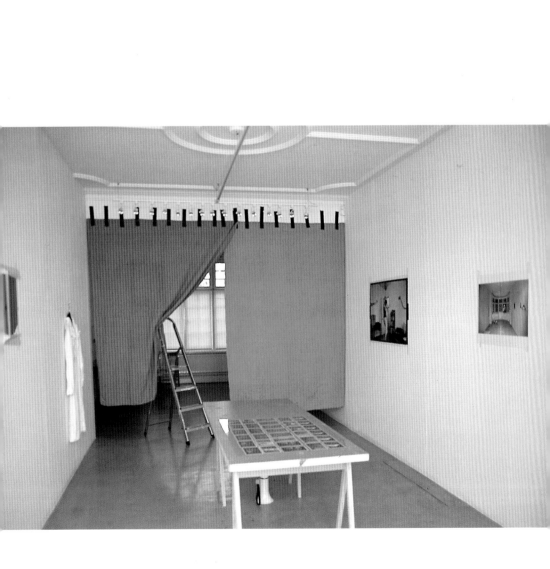

What is drawing? Lucy Gunning **93**

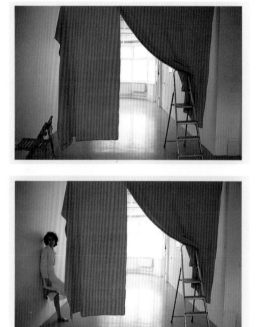

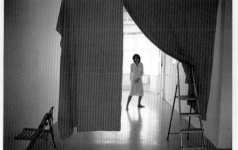

Blankets

thirty-two 'Snappy Snap'
photographs, 2002, each
photograph 15 x 10 cm

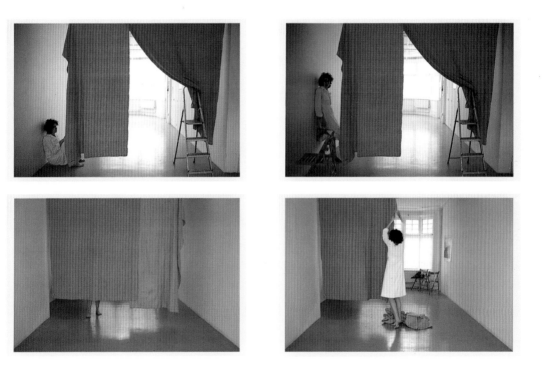

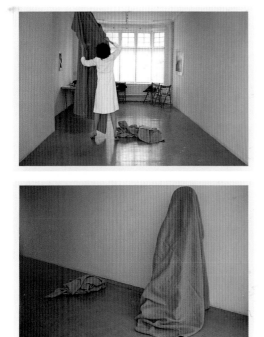

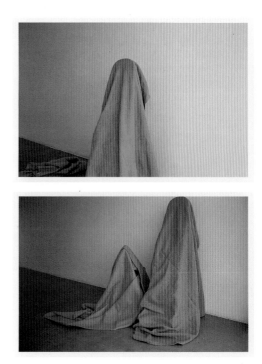

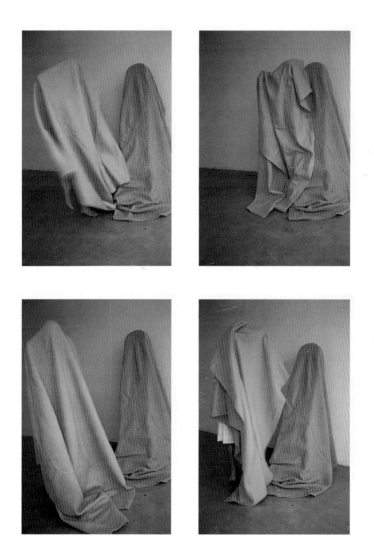

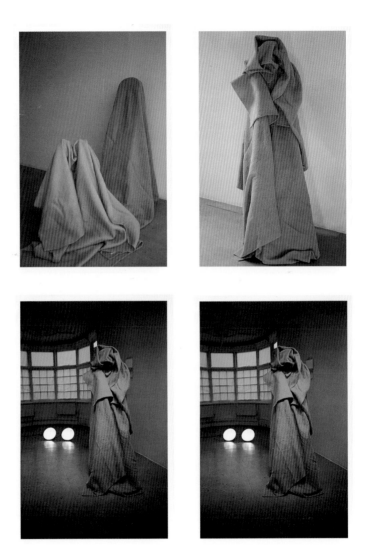

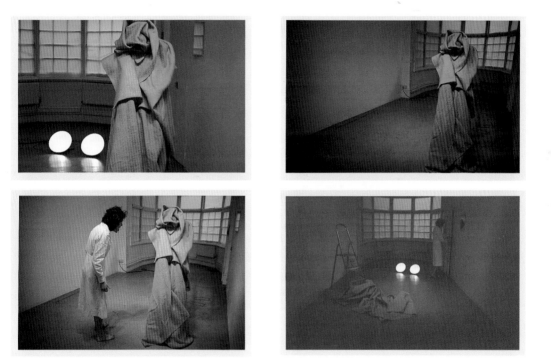

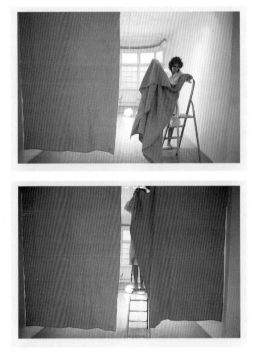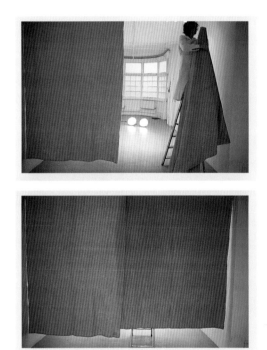

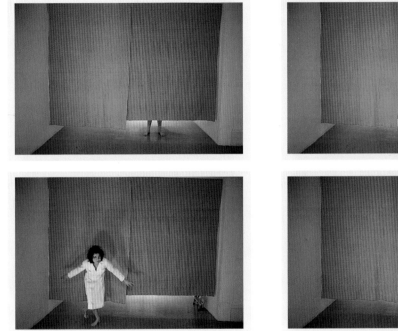
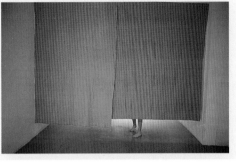
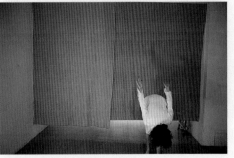

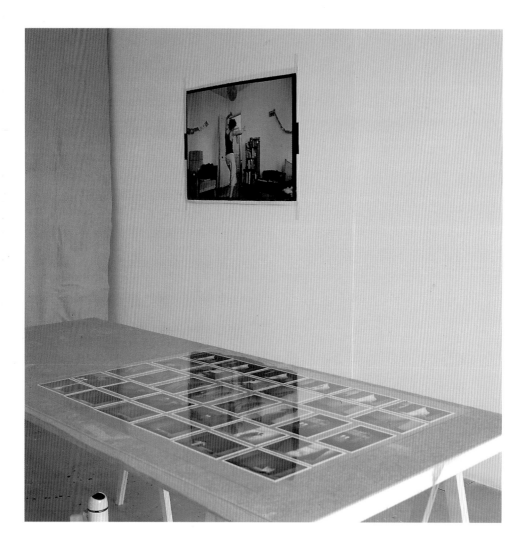

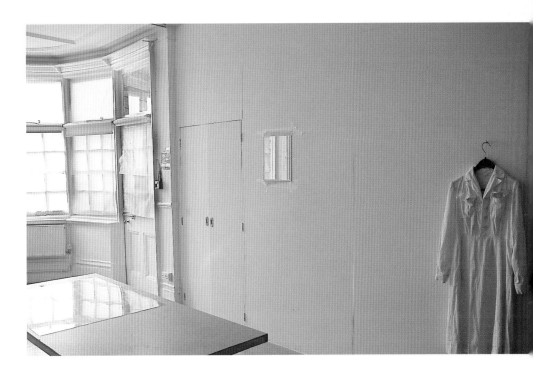

Lucy Gunning's
exhibition, March 2002

two pink blankets,
gaffa tape, megaphone,
two tables, ladder,
white dress, mirror,
tripod, photographic
lights, photographs,
photocopies, drawings,
glass, masking tape,
streamers, chair

Lucy Gunning lives and works in London. She was born in Newcastle upon Tyne in 1964 and studied at Falmouth School of Art between 1984 and 1987, and then at Goldsmiths College, London, from 1992 to 1994.

Gunning's solo exhibitions include: Adam Gallery, London, 1995; University at Buffalo Art Gallery, New York, 1997; Matt's Gallery, London, 1997, 1999; Galeria Presenca, Porto, Portugal, 2000; GreeneNaftali Gallery, New York, 1996, 1998, 2001; Tate Britain, London, 2001; and Westfälischer Kunstverein, Münster, Germany, 2001.

She has exhibited in numerous group exhibitions, including: *BT New Contemporaries* (touring), Anthony Reynolds Gallery, London, 1994; Centre Georges Pompidou, Paris, 1995; Museum of Modern Art, Toyama, Japan, Manchester City Art Galleries, 1996; British School at Rome, 1997; Real Art Ways, Connecticut, 1999; Henry Moore Institute, Leeds, 2000; ICA, London, *British Art Show 5* (touring) and Palm Beach Institute for Contemporary Art, Florida, 2001.

In 2001 Gunning was awarded a Rome Scholarship at the British School of Rome and undertook a two-month DAAD residency at Münster, Germany.

Her work is included in the following collections: The Arts Council Collection at Hayward Gallery, Centre Georges Pompidou, Contemporary Arts Society, Museum of Modern Art, Toyama, and Tate Gallery.

She is represented by Matt's Gallery, London, and GreeneNaftali Gallery, New York.

Flowers in Hair
photograph, 2002,
16.5 x 25.5 cm

Rae
Smith
in
conversation

Hilary Baxter: Where did you begin with this residency and how did you approach it?

Rae Smith: I began by walking into an Edwardian downstairs living room of a semi-detached house in a leafy Wimbledon suburb. The room was painted white, no detail. I then shut the door behind me.

I was actually quite shocked to find myself on my own, in a rather lovely white room with no one to talk to. Away from the theatre – working in collaboration, the habit of thinking and doing together – I was now like an actor in a fine art environment. I had to rely on an internal dialogue, a solitary role with myself as the subject matter undergoing a process of devising in a site-specific environment. There was a discipline to it: think what to do/do it/look at it/think what is it/make it more or less so. And that I had to use what I believed about the theatre on myself.

I sat down in the room. In my mind's eye I saw a spinning shape in the vast grey-white space. As I looked closer, I saw it was a house and because of the grey-white space, it took time to see and realise that it was a little house spinning round. I was thinking, what is the house? As soon as I thought that, my mind made it into a jewelled casket. I saw the framework of the house within the casket and it was very similar to a mediaeval mnemonic framework. Within the architecture of the mediaeval church there were sections of space which would allow stories to be told. The stories would have a timeline to them, punctuated by the ideas of seasons, or festivities, or the narrative of Christ's life. Before mass literacy such mnemonic structures were used to memorise psalms and, in traditional storytelling, very complicated stories which in the mind's eye could be held in this casket or chamber of memories. I set myself the problem of making one.

On my first day I used a chalk line and drew out strips of the architecture around the room, so that I could put the images from my imagination, my memory of my own life, within it. I would use this time for self-reflection, with memories envisaged almost like a succession of scenes.

But as I began to carry this out – normally I have an idea and then draw it – I became less interested in the concept and more immediately attracted to the abstract qualities of each mnemonic drawing and how that physical object, and the memory of it, related to me. Drawing directly onto the walls with fluorescent pens heightened that relationship. It seemed that what was drawn was absolutely directed at you. The nature of fluorescents which reflect light provokes a dynamic in which the onlooker is responding to what is shown. This tells another story about the energy of the drawing: that you could hardly ever look at the

whole drawing all at once and that there is a potent afterburn of the image in the mind. I also began to use white on white and to use it in three-dimensional space. That's as far as I've got at the moment.

HB: I'm interested in some of the differences between working as a designer and working in fine art practice. What pleasures there have been in working for yourself, in making connections simply through your own practice?

RS: The toughest thing about being in a residency, where you show the work to visitors as you do it, is that sense of being lost in space. And having to get rid of your habits which are to do with delivering. In the theatre I do up to seven artistic projects a year and deliver on the dot on every one. Could I be brave enough to throw all that discipline up in the air? To have a space where I could simply have time to do and think and be, sounds fantastic, but I found myself confined by my own habits and occasionally able to punch through a little gap. I used devising techniques to be able to do that – which didn't mean I did exercises and sung every morning. Far from it. But, I did try to remember that when I made things complicated it was because I was trying too hard and when I was trying too hard, the answer was to make it simpler. Or not to make it at all, just leave it for a bit until something comes up.

HB: I'm going to change tack completely now and ask whether your use of drawing has been affected by new technologies?

RS: Light, sound, fluorescent magic marker pens, space. That's all. For this project the technology becomes a synthesis of what's happening rather than a concept in its own right. As a rule I don't like technology to get the better of me.

HB: There is a story about the magic marker isn't there?

RS: Well, I didn't actually realise this until later on. But my grandfather, who I was very close to, died last year. When I was a little girl I lived in his house and I got given a small set of felt pens, one of those packs with different colours. I was put to bed far too early one day in the summer, about half past five, and I had this vast blank white wall in my bedroom. I drew: I stayed up all night, drawing this huge town on the wall. It was a mouse town and they all had big mouse ears and noses, and everything you could want: there was a sweetie shop, a playground, a circus, a cake shop, a train, a swimming pool. Eventually I fell asleep and my mum came and found me, about half past eleven (so it wasn't really all night, but it was if you're small), and put me to bed covered in felt pen. My grandfather, who came in the next morning, was furious! He didn't see it as a small person's visualisation of paradise; he just saw it as a bloody mess all over the wall. He painted it over immediately and I sat there

watching him painting it over. He was a very old-fashioned man, a very patriarchal, working-class man, and this was his response to art: it was a mess. I was quite vexed by this and my vexation made him feel more and more guilty and eventually, when he moved house, he let me draw all over the walls before they were painted. But, by that time, I was at least nine and I couldn't see the point of it.

When it came to this residency, I ended up using some money he had left me to have some time off work, so that I wouldn't come into the drawing space with my head full of theatre. And on the first day in the art shop, I was deeply attracted, strangely enough, to these fluorescent felt pens, and thought: "On the wall! Must draw on the wall!" It brought me back to being that person again. I found that my grandfather had in fact not only paid for me to do some thinking before I started work here, but also was probably having a laugh at what I was doing, right now.

HB: I know that the drawings that you have made, and the ones that you intend to make to finish the exhibition are very much based around memory. How do you describe the relationship between imagination and drawing?

RS: Imagination in drawing has a very direct link, a physical link, from the visualisation to the hand that expresses the thought. At first the drawings based on memory came out like film storyboards, which I wasn't too happy about. I then took two real life events: one was working on a play, *The White Devil*, which is a Jacobean tragedy of hell, horror and damnation, written by John Webster, and the other one was a real life murder that I witnessed in former Yugoslavia. I drew those as comic strips and they lived on the wall opposite each other for a couple of weeks. And even though the memory of the play was quite exciting, with its blood, stabbing, murders and hellish Machiavellian carryings on, that was quite easy to draw. I realised that I was very interested in the woman character called Vittoria Corombona. She's perhaps the most complex character and one of the most fantastic parts to play as an actress, mainly because she gets bought, sold, raped, murdered – she really goes through the mill of the moral ambiguities of the society and the men involved. I found myself simply telling a story through drawings about her.

When I was drawing the real life event of the murder it wasn't so exciting and I just made horrible drawings. The main character and my role in the story was ambiguous. It was really difficult because the link between the strong emotions of the memory and the drawing of it was disconnected.

HB: How are these drawings connected, and how would we grasp the connections or the differences?

RS: The connection is me as the point of view. And the similarity and differences between the art of theatre and real life. In theatre I am a

visual storyteller and in life I bear witness. This bearing witness is at the heart of the exhibition. Not just in the darkness of the murder drawings but also in reflected light, in the story of love represented by a diving dolphin. The subtlety of white on white make the drawing impossible to photograph or record: you catch it in glimpses between water and light. The experience of looking puts the image together.

HB: When we spoke earlier you said that when you came here you felt a bit like a Victorian. I just wondered what you meant by that?

RS: I feel like someone from the nineteenth century as opposed to now, mainly because of the idea of drawing descriptions of events that had happened as opposed to photographing them or recording them. Actually, my drawings did look a bit Victorian in style, as well, except they were in bright green, fluorescent yellow, orange, yellow or white ink. That was deeply shocking, because I found myself without any idea of modern art in my drawings. With the exception of the fact that a lot of the drawings had the point of view of a camera's eye view – looking down from above, looking around the corner onto something – and also would have a choreographic sense of space in them as well, which would be to do with the theatre.

I had a long think about the theatre in that way, because the Victorian proscenium arch is something that I work inside a lot of the time and it's a strange space: it has particular rules. For example, it has a picture frame around it. And like Renaissance painting there is a sightline of diminishing perspective that maps out on the floor like a triangle. The front of stage, the nearest part to the audience, is the triangular base. Standing there everyone can hear and see you very clearly and you can have a very direct and intimate relationship with a huge audience. You step back, say two metres, a few more people join you, and then you're seen pictorially in terms of a group. Step back even further, say you're four metres from the front of the stage, and you are part of the entire picture, part of the landscape.

You can see this in naval paintings. The people who painted the scenery of the theatre from the 1740s to the 1860s, all those people were naval artists or they were in fact sailors who painted and then went into the theatre. We still talk about the flying and the rigging and it is bad luck to whistle on stage, which comes from orders being whistled on ship. I realised that part of my imagination stems from that historical background. It's a type of Victorian capitalist realism, where you have an individual, who then steps into a family group, then steps back and becomes a part of the society or the environment where he lives. Also, a lot of the way the news was told in Victorian times, through paintings

and engravings, connects with melodrama – which is very often about the one man, his family group and how society influenced or responded to his misdemeanours.

Now, I don't necessarily work within the proscenium arch: I work in the round, in spaces, build installations and environments, but a Victorian aspect still survives in that theatre work is mostly based on narrative storytelling. I would like to depart from this.

HB: When we began you talked about arriving in the room. What do you hope to leave?

RS: Exhibitions have to come and go and take their chance in memory, just as plays and performances do.

Detail of **Dream**

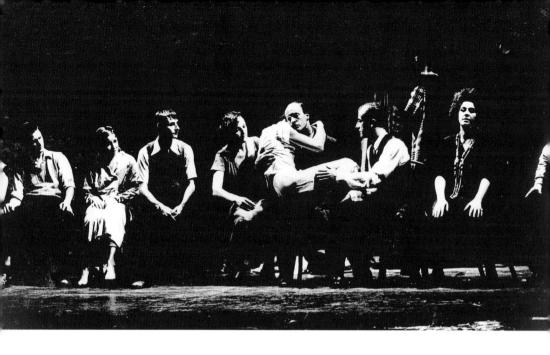

The Street of Crocodiles

based on a story by
Bruno Schulz adapted
by Simon McBurney and
Mark Wheatley, Théâtre
de Complicité, Queens
Theatre, West End,
directed by Simon
McBurney, designed by
Rae Smith, 2000

photos: Nobby Clarke.
Actors in photos: Joyce
Henderson, Eric Mallet,
Stefan Metz, Cesar
Sarachu and company

(and on next page)

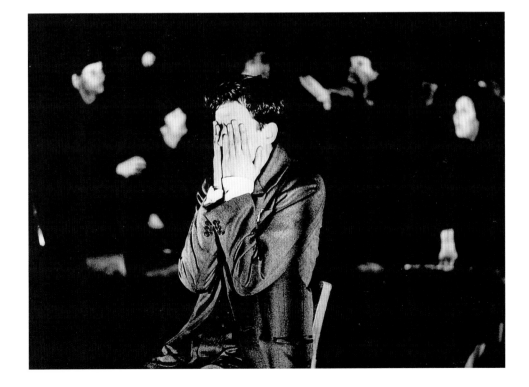

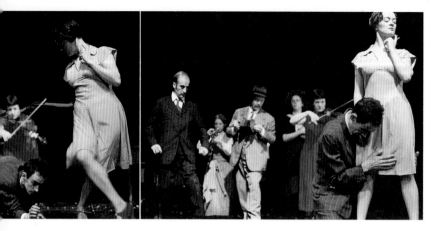

Above: **The Street
of Crocodiles**

Right: **The Prince
of Homburg**

by Heinrich von Kleist,
Royal Shakespeare
Company, Lyric Theatre,
Hammersmith, directed
by Neil Bartlett, designed
by Rae Smith, 2002

photo: Rae Smith. Actor
in foreground: James
Laurenson

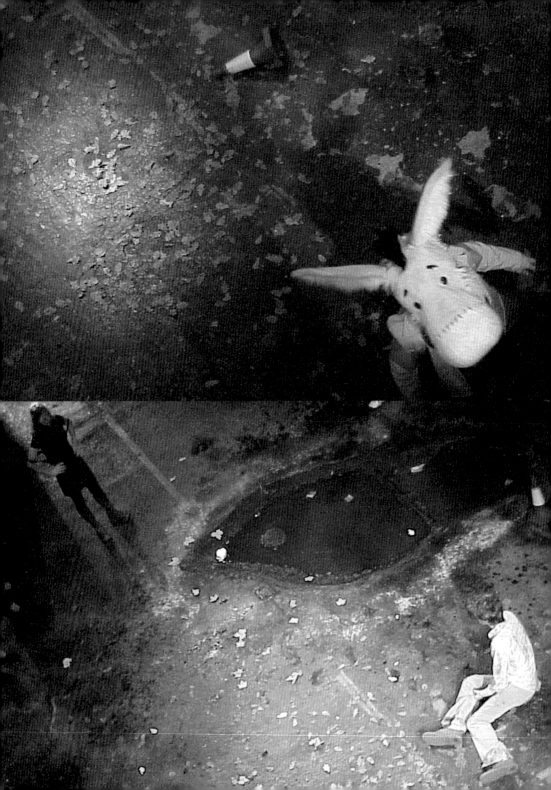

**A Midsummer
Night's Dream**

by William Shakespeare,
Royal Exchange Theatre,
Manchester, directed by
Lucy Bailey, designed by
Rae Smith, 2002

photos: Rae Smith. Actors
in photos: Jonathan Bond,
Tom Hodgkins, Paul
McEwan, Fenella Woolgar

Rae Smith: What drawing feels like

Having collaborated with Rae Smith on seven pieces of work for the theatre, I am used to encountering her drawings as part of the working process of putting on a show. When we collaborate (she designs, I direct) drawings are the most effective means of summarising or explaining our ideas for the realisation of the piece, both to each other and to other people. These theatre drawings, though they are often (or indeed usually) incidentally beautiful, are drawings of a particular kind; explanatory, illustrative and disposable. The drawings published here are something different; they were, for instance, made in private, not in collaboration, and they were meant for exhibition.

Because of its usual scale, and its traditional materials, and because it is so intimately to do with the workings of the hand, drawing comes closest to handwriting in the index of forms of expression. A drawing is often almost an unintentional autograph, a signature. Sometimes Smith delights in this aspect of drawing quite directly, with rapidly executed ink sketches that are torn out of a notepaper-sized sketchbook and simply 'Blu-tacked' to the wall – memos. Even when the drawings are blown up to an unframable scale, and made directly onto the wall, they still carefully retain their hand-drawn-ness. They are still clearly 'pages' from a notebook. In addition, the pages seem to be from something as near to a journal as to a sketchbook. Traditionally, the sketchbook accompanies the artist and is used to quickly record impressions while she is outside, travelling, impressions which she will then work up into something else in the privacy of her studio. In this case, not just the working-up but the journeys themselves have been made within the locked room of the studio. They are all journeys into memory or enquiry – especially memory. There are no life-drawings or *plein air* landscape sketches here. These figures and landscapes are all remembered, seen with the mind's eyes. What is remembered is then recorded, reworked and recontextualised within an elaborate and self-reflexive notion of what a 'simple' thing a drawing is.

The room that Smith has made takes the idea of an exhibition of drawings, and turns it into a small theatrical event – an event for an audience of one (on reflection, that probably makes it an installation; however, I strongly suspect that she wants the viewer to 'perform', and be aware of performing, the act of looking at her drawings, so I'll stick with the notion of theatricality – after all, there is atmospheric and technically contrived lighting, every surface is treated and dramatised, there is a soundtrack, programme notes, a clear sequence of events, an expressive climax in the final drawing before the end...). The room in which she has installed the work has been worked and manipulated so that each drawing is a contributory part of an overall experience of the space itself, and of the time that the individual viewer spends within it. In this respect, I think that her model (subconscious or conscious) is not the obvious one of a white-painted art gallery, but rather a tiny whitewashed mediaeval chapel – somewhere like the one at Coombes in East Sussex which we visited together in the winter of 2001. The walls of this intensely atmospheric space are covered in sporadically visible traces of all-over eleventh-century wall paintings of extraordinary vigour and delicacy. The paintings – or wall-drawings – are so decayed that you need to look very hard to see what they are of, and even where they are; even so, the viewer is aware that all the fragments are part of a larger scheme. Smith has made the accidental effects of this painted chapel deliberate. In her room also, none of the drawings are in black and white, or framed, or easily visible. They are too big, too small, spread across architectural features, too high, too low, too detailed, too incomplete. Even when they are perfectly preserved and legible, they are in eye-exercising fluorescent ink, or in evocative white-on-white. The viewer must work, quite literally, to see them, and in consequence, to feel them. However, they never intend to frustrate; they always work to encourage concentration, and resonance. The effect, as in the chapel, is as emotive as it is pleasurable.

As in a mediaeval church, drawing here has several both distinct and overlapping functions – it is by turns mnemonic, educative, iconographic, narrative, devotional and decorative. This is in part an effect of summarising the various fruits of an intensive period of full-time studio work; Smith is quite unapologetic about refusing to limit 'drawing' to one particular or privileged function. The drawings of men storytelling or playing music are terrific celebrations of a personal taste for virile energy; drawing as manifest enthusiasm. *Dream* is an evocation of a mood, a storyboarded urban landscape which houses a fantasia on freedom; drawing as contemporary pastoral, escaping from two dimensions just as the mind escapes the city. Pieces like *Door* or *Dragonfly* unashamedly use drawing to work something out – they are sketches of ideas, quite literally. If importance is to be measured by intensity of feeling, then the two most important drawings in the room are *Scissors* and *Medja*. Several kinds of drawing are here combined to complex effect. An apparently random stack of pages torn from a sketchpad allude to the traditional sketchbook attempts to fix an image before transferring it to canvas, but in fact the repetition here re-enacts the compulsive re-viewing of a horrific and unwanted memory.

A mechanically finished, hypnotically simplified drawing of a monstrously oversized pair of scissors, looming out of whiteness, eliminates nearly all traces of the artist's hand, just as the scissors themselves, in the narrative alluded to, eliminated life. Finally, the barely visible (as if barely endurable) drawing of the stabbing of a child returns us to the simplest, most elementary kind of mark-making. These marks don't represent or illustrate the stabbing strokes which killed the child; using a gesture identical to the killer's – an act of exorcism as much as of sympathy – they re-enact them.

These works are absolutely private. After all, that is another important characteristic of drawing; because it is so cheap and quick, you can afford to do a lot of it, just for yourself. They are also absolutely public. They exist to provoke and invigorate. Men worth admiring; a marvellous dolphin; a tits-to-the-wind free-falling Goddess; the almost unbearable memory of seeing the killing of the child; by drawing these things for us, and in so doing making such a skilful exhibition of herself, Rae Smith turns the determination to return to drawing as the basis of her work into a particular and admirable form of courage.

Neil Bartlett

This page: **Herod (?)**

Opposite: **Angel appearing to Joseph and prying Jews**

11ᵗʰ Century wall paintings, Church of Coombes, near Lancing, East Sussex, courtesy of the Reverend Roger Russell

photos: Ann Ballantyne

IN THE THEATRE I AM ALWAYS DRAWING, AND ALWAYS QUICKLY: AS A REACTION, A DIRECT FORM OF COMMUNICATION OF IDEAS WITHIN THE COLLECTIVE PROCESS OF MAKING A PIECE OF LIVE ART. SOMETIMES I DRAW IN A COOL, UNATTACHED AND TECHNICALLY EFFICIENT WAY, AND AT OTHER TIMES, FOR EXAMPLE, AS A WAY OF RECORDING THE DEVISING PROCESS OF AN ACTOR. WHEN THE ACTOR IS TRYING TO ANIMATE THEMSELVES PAST WHAT IS CONSCIOUSLY BELIEVABLE, DRAWING CAN BE A MIRROR, AN INSIGHT INTO WHAT WAS ACHIEVED IN A FLEETING MOMENT. DURING THE TECHNICAL PRODUCTION WEEK, AND AFTER THE FRENZY OF THE DEVISING PROCESS, I DRAW RANDOM MOMENTS FROM THE PLAY. THESE DRAWINGS WILL LATER REMIND ME OF HOW I UNDERSTOOD THE WORK AND PROCESS.

WORKING OUTSIDE OF THE THEATRE, AND NOT AS PART OF A TEAM, I WILL BE MAKING A DIFFERENT USE OF DRAWING, EXPLORING IT FOR ITS OWN SAKE. I WILL BE THE FOCUS AND WILL CONCENTRATE ON MY OWN IMAGINATION AND MEMORY. AND THERE WILL BE TIME TO DO IT, AS I HAVE HAD NO SUCH TIME SINCE BEFORE I WENT TO SCHOOL. I WOULD LIKE TO PLAN FOR SOMETHING UNEXPECTED TO COME UP. HOW DO YOU DO THAT? I WOULD LIKE TO GO WITH WHATEVER WAY IT TAKES ME AT WHATEVER TIME, AND TRUST MYSELF, AS THE CROSSING OF THE BORDER FROM THEATRE INTO THE FINE ART TRADITION MIGHT BRING ON A CULTURE SHOCK.

Rae Smith, May 2002

Works in progress in Rae Smith's Studio

Haïdouks

fluorescent ink on
paper, 2002, each
drawing 21 x 15 cm

(continues on next page)

What is drawing? Rae Smith

Looking out to Sea

fluorescent ink on paper,
2002, 15 x 126 cm

Medja

mixed media on paper,
2002, each drawing
21 x 15 cm

(continues on next pages)

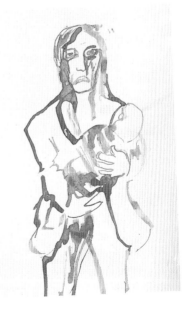

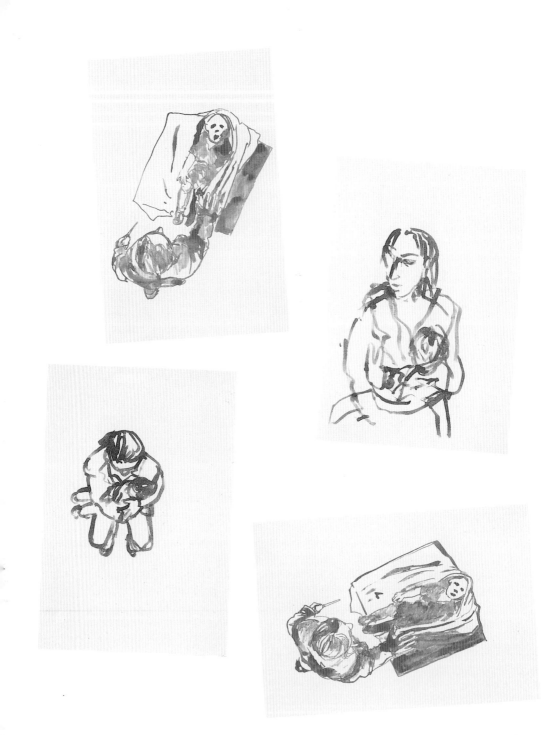

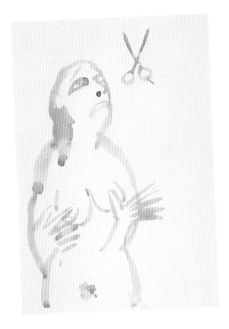

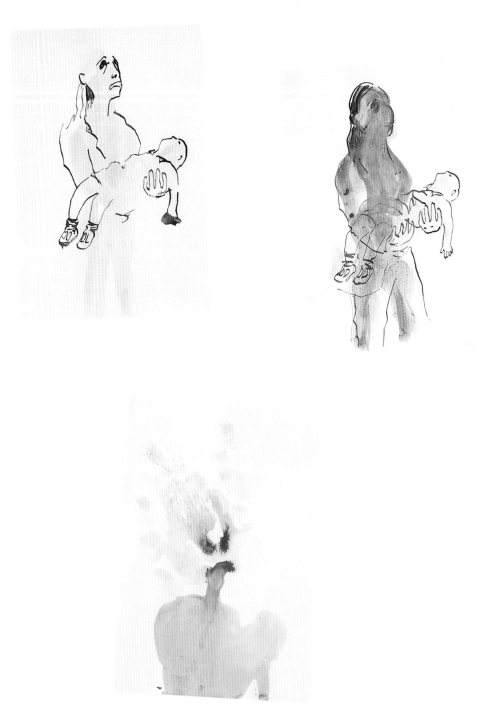

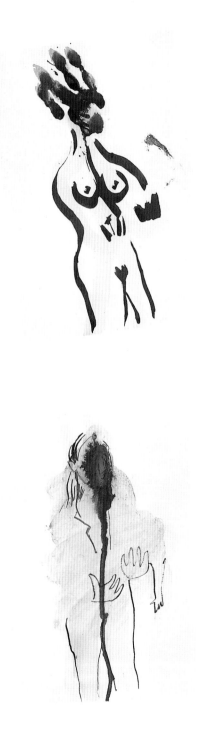
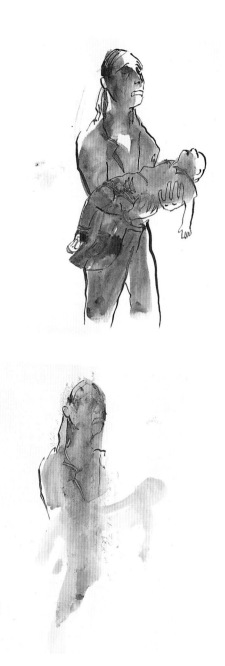

Falling Venus

ink on paper, 2002,
228 x 22. 5 cm

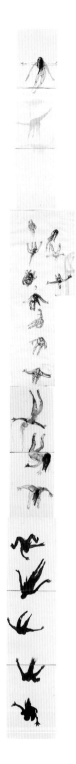

Dragon Fly

fluorescent ink on
paper and wall, 2002,
215 x 275 cm

(detail overleaf)

Haïdouks

Rae Smith's exhibition, June–July 2002

(and on following pages)

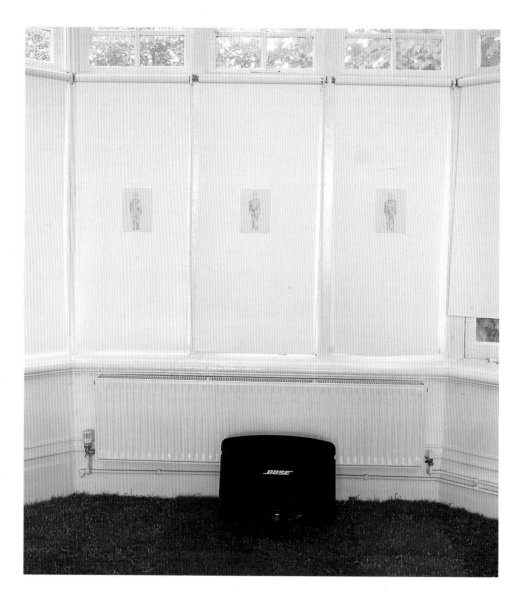

Door, **Scissors** (white on white drawing, not visible in photo),
Medja, **Dream** and flower

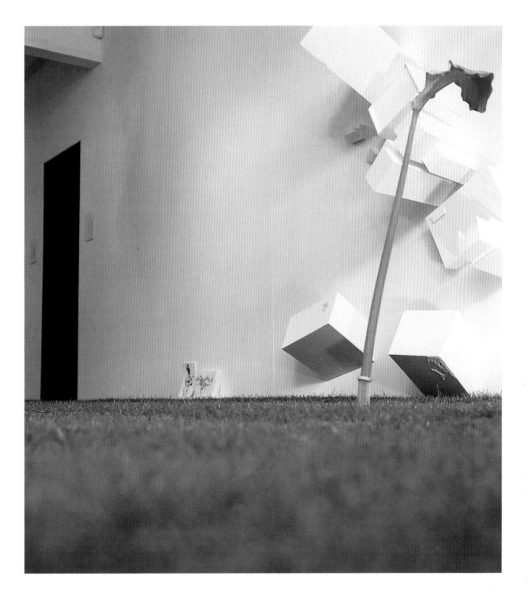

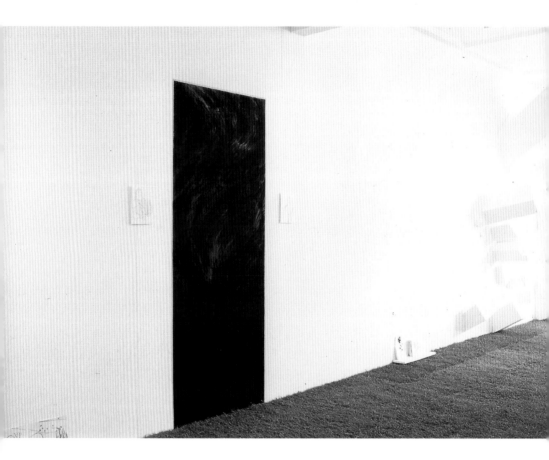

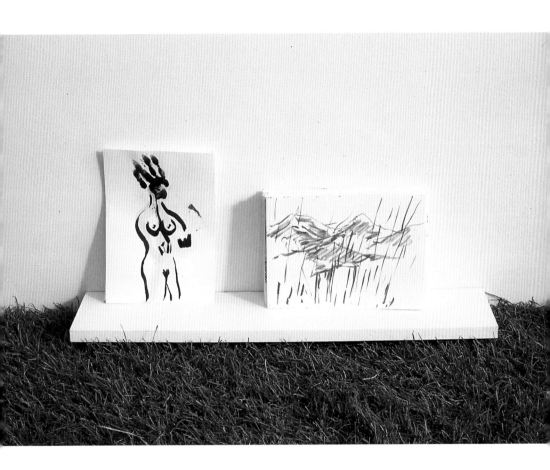

What is drawing? Rae Smith

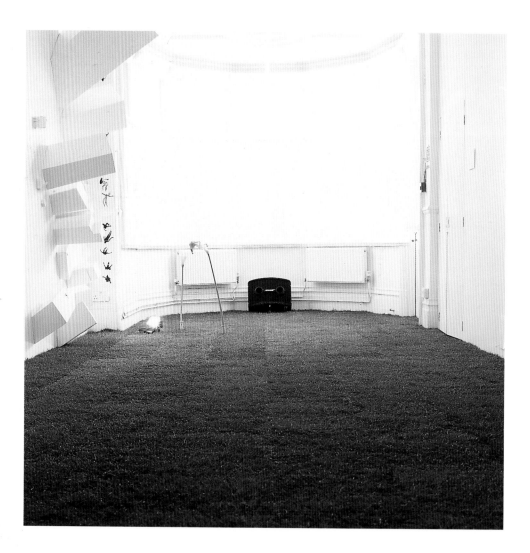

What is drawing? Rae Smith

146

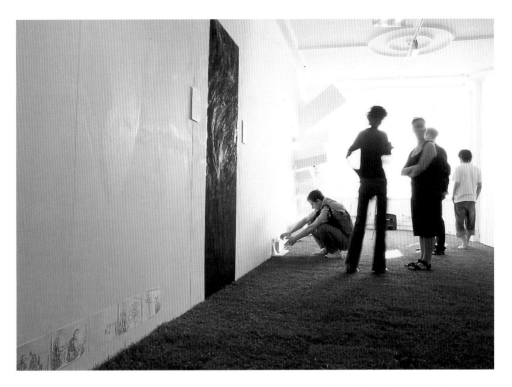

Two large white on white direct wall drawings, **Dolphin** and **The Baby**, were resistant to being photographed. Indeed, they were visible to visitors only if they moved to catch the light on the drawn white marks. However, other white on white drawings, **Scissors** and within the wall sculpture **Dream**, are partially represented on these pages.

Rae Smith's installation included a specially composed soundtrack by Sarah Collins, lighting by Bruno Poet and models by Wil Fricker.

Materials: white and fluorescent ink, paper, foam board, turf, sound equipment, flowers, tumbler, cigarette packet.

Born in London in 1962, Rae Smith studied Theatre Design at Central Saint Martins College of Art and Design between 1982 and 1985. Her work includes opera, West End, Broadway, European avant-garde, and classical and contemporary plays.

Rae Smith's design credits for 2002 include: *Crazy Black Mother F***ing Self*, Royal Court Theatre, London; *Closing Time*, Royal National Theatre, London; *Port* and *A Midsummer Night's Dream*, Manchester Royal Exchange Theatre; *The Prince of Homburg*, Royal Shakespeare Company, Stratford-upon-Avon and Lyric Theatre, Hammersmith; and *The Magic Flute*, Scottish Opera, Glasgow and tour (to 2003). Previous projects include *The Weir*, The Royal Court Theatre, London and Walter Kerr Theatre, New York, 1998; *Silence, Silence, Silence*, Mladinsko, Slovenia, 1999; *The Street of Crocodiles*, Queens Theatre, West End (2000); *Johnson Over Jordan*, West Yorkshire Playhouse, Leeds, 2001; and *Juno and the Paycock*, Roundabout Theatre, New York, 2001. Operas include *Don Giovanni*, Welsh National Opera, Cardiff, 1998; *The Maids*, Lyric Theatre, Hammersmith, 1999; *The Turn of the Screw*, Brighton Festival, 2000; and *The Magic Flute*, Opera North, Garsington Opera, 2001.

She has also written, directed and designed *Lucky*, David Glass Ensemble, UK tour, 1998; *Mysteria*, Royal Shakespeare Company, Stratford-upon-Avon, 1999; and *The Terminatrix*, Royal National Theatre, London, 2000 and The English National Opera Studio, London, 2001. In October 2001, Rae Smith gave a live drawing performance using an over-head projector to accompany *Frankenstein* at The Royal National Theatre Studio, London, 2001.

She has published her drawings widely and exhibited at the Third Eye Centre (now CCA), Glasgow, 1990, and with NSK, an arts collective in Ljubljana, Slovenia, 1992. In July 2002 Rae Smith was artist in residence at Cove Park, Loch Long, Scotland.

Drawing from **Medja** series

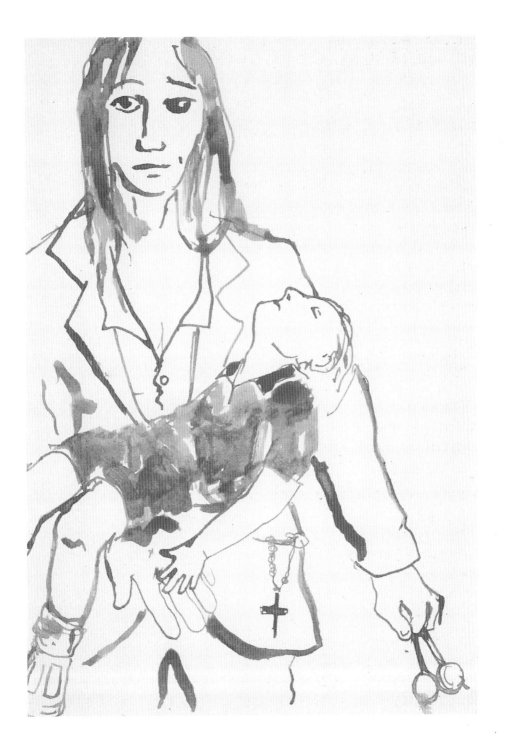

Drawing things in, sketching things out

And again my inmost life rushes louder, as if it moved now between steeper banks. Objects become ever more related to me, and all pictures ever more perused...

Rainer Maria Rilke, "Progress", from *The Book of Images* (1902)[1]

Much of drawing's vividness stems from its innate ability to forge an immediate link between what we think and what we sense. That a dialogue between our thoughts and our experience of the real might be borne out by the simplest of pencil lines is what counters drawing's other, more restrictive aspects – its pedagogical presence in the art school curriculum, its ties to the study of the human form, the servility implied by its academic function as copy, or the monochromatic realm of dark trace on white support to which it is bound by tradition. The dialogue, in other words, is what sets drawing free. This idea has a long history. For a champion of *disegno* like Leonardo da Vinci, drawing might thus be construed as something more or other than the necessary first step in the progression towards a final painting. Drawing was understood by Leonardo to be "part of a process", as Ernst Gombrich observed, "which is constantly going on in the artist's mind; instead of fixing the flow of imagination it keeps it in flux."[2] On the one side, then, there is "fixing the flow of imagination" in the preparatory sketch, which signals the impending arrest or fixing of thought in the ensuing, highly crafted image towards which the sketch is directed. While on the other side, there is an imagination kept "in flux" by a continuously unfolding practice of drawing unmoored from the making of a finished work of art. Drawing's relation to the painted or sculpted masterpiece is incidental. The link is there or not. The real point is to sustain the movement of personalised languages of the trace as they migrate from page to page, notebook to notebook, surface to surface.

Such a mode of drawing might have prompted the American art critic Clement Greenberg to regard Leonardo's drawings as "sheer rumination, revery, wish-fulfilment, thinking [that] amount to works of art only in the limited way that isolated passages of verse do – or even less, because their presumptive wholes never saw existence."[3] But this, too, is progress – of another sort – though not in the sense

of progressing towards the compositional resolution of a single canonical work such as *The Virgin of the Rocks*. Progress here has to do with keeping attuned to what Rilke described, in the passage of verse from "Progress" that I isolate in epigraph, as the increasingly loud rushing of an "inmost life". Although Rilke's poem does not mention drawing per se, it nonetheless offers a potential account of the triangulation elaborated by the draughtsman's hand between pictures, objects, and thoughts. To the image maker, drawing (like poetry itself) is a means of testing out how an "inmost life" causes objects to "become ever more related to me, and all pictures ever more perused".

Claude Heath, Lucy Gunning and Rae Smith all explore the relation of pictures, objects, and thoughts in ways that fall squarely into the domain of drawing inhabited by Leonardo: drawing as an activity that exemplifies an imagination in flux. This is all the more interesting in view of the fact that the actual corpus of works by the practitioners in question would seem, at first glance, to find little (if any) echo in the representational spirit of Renaissance humanism. Claude Heath, for one, stresses the relevance to his work of an artificial field of media vision (flat-screen televisions and computer-generated digital imagery). Rae Smith, meanwhile, is a theatre designer whose sets and collaborative productions have been aimed at radicalising the visual impact of the scenographic spaces in which she works. And Lucy Gunning ultimately ousts drawing altogether from her variously contrived installation pieces. Given the tendencies implied by their visual and verbal statements, it seems clear that these are contemporary artists whose concerns run considerably far afield of those bolstering the mimeticism of High Renaissance painting and sculpture. But look again. For it is precisely in the inconclusive repetitiveness of Heath's still lives, in the glowing transparency of Smith's wall drawings, and in the fleeting spurts of sketching in Gunning's installation that the

provisional nature of drawing (to which Leonardo was deeply attached) resurfaces.

Consider Heath along these lines. His self-imposed working methods derive quite self-consciously from a sculptural sensibility or way of proceeding. He insists on being "tactile", as he puts it, as well as ambidextrous – this despite the linearity, colourism, and openness of form in the outcome. Such optical qualities notwithstanding, the notion of a tactile drawing emerges as the single most important aspect of Heath's creative venture. "There's no single point of view", he explains of the object:

When I drew the Willendorf Venus, someone said "you couldn't possibly draw that just from touch only" ... so I had to try. But to draw it and then to turn the object became fascinating because the perspectives of this figure that was turning became very, very condensed.... It's how to arrive at a point where something like that can happen. You have to set up all these rather elaborate methodologies.

The methodologies, or self-imposed restrictions, are unquestionably elaborate. Heath looks at the plant not the sheet, peruses the object not the picture, and draws from underneath or from the side rather than head on. Such an approach, which combines serial beginnings and simultaneously worked surfaces with an intentional blind spot, finds notable historical precedents in which blindness and insight are likewise yoked. We might think of Raphael's blind stylus underdrawings, for instance, in which the traceless indentations left behind by a metal-tipped instrument relinquish mimesis altogether to denote an invisible touch that draws its confidence from not looking at the image underway.[4] For Raphael, the stylus was not restricted to its traditional workshop function as the tool of choice for transferring a given design from a cartoon. Rather, it cleared the way for sketching freely by liberating the hand from any commitment (otherwise made by pencil and pen) to the visible trace. We might also remember the apocryphal story, recounted by the French diplomat and art theorist Roger de Piles in 1708, concerning a blind sculptor whose "eyes are at the tips of my fingers. ... Drawing, as I said, is still the aim of touch."[5] Heath updates these ideas. For him, touch in drawing translates into a colourful linear network which, in a set of images like *Two Fold Drawing/Four Plants*, works to collapse multiple perspectives into the fragile abstraction of two-dimensional webs. But where the three-dimensionality implied by the idea of a (sculptural) touch in drawing ultimately gives way to the flattening out of the

object's spatial presence on the picture plane, its temporal presence, by contrast, is made potentially infinite by the folds and repetitions of the working methods themselves. Space collapses while time extends in the haunting sameness of Heath's coloured circuits. The idea of finishing is inconsequential for this pictorial world in which meandering is so central – a meandering that brings objects closer to the artist's hand then exposes pictures to the viewer's perusal.

The meandering – or lack of fixity and purpose – is in some ways unexpected. Perhaps working in a space destined to be transformed from studio to gallery in only six weeks would seem to call for finalised images, for conclusive public statements, for self-conscious progressions and clearly determined ends. But equally it might have encouraged and thus given value to the meandering. It is arguable, from the image-maker's stand point at least, that the daunting *tabula rasa* evoked by walls as white as blank pages can only be met with hesitancy. Small wonder that Gunning would speak of the "hand-held fluidity" that links drawing to filming, of the "learning process" and "accidents" marking her stay, as well as of the productive "tentativeness" of the situation in which she found herself. Especially for an artist such as Gunning, who often incorporates video into sculptural arrangements, the drawing residency must have been an intense sort of challenge. How could drawing – with the secrecy, solitude, and self-absorption it inevitably seems to call for – possibly find an expressive place in a symbolically and psychologically charged approach to art that relies for its effects on the fact that spaces, objects, and identities are enacted by the artist *with* and *through* her audience? By way of an answer, Gunning begins by domesticating the studio with casual sketches of flowers and things, moves onto photographs, and dreams of an escape from the white box. A feminised space? At some point pink curtains part beyond a white dress suspended from a hanger, so that a room once marked as private can be divided between spectators and stage. The room is now a theatre in which the monster – a strangely anthropomorphic presence, a temporary statue made out of blankets – is exposed.

It is not surprising that Gunning's installation might strike some as having nothing whatsoever to do with drawing – nothing, that is, to do with producing and displaying an actual set of drawings that represent, or at the very least, show or point to the world in some way. Yet what is a monster, etymologically speaking? As the historian Caroline Walker Bynum reminds us in her magisterial essay on

wonder, *monstrum* (or monster, omen, sign), is linguistically tied to *demonstrare* (to show, to point, to represent).[6] Following the lead of its verbal counterpart, the image of what Gunning calls "my monster" might be taken as a metaphor for the task of representation itself. Drawing, when seen in this light, appears not as a concrete line on paper but as a performance about representation – representation, which is enacted by means of objects drawn in through thoughts and experiences then sketched out in still-lives, photographs, and monumental physical forms. In fact Gunning, more than the others, seems to have taken up the problem of drawing's traditional place as point of entry into the artistic process. "The destination is the journey", she explains, meaning that the necessary conflict between throwing oneself into the unknown and working towards a final show was the most productive aspect of showing, pointing, and representing. The conflict finds resolution, ultimately, in an artistic journey that begins with the drawing (the picture) and ends with the monster (the object-sign of representation).

Smith, too, is troubled ("shocked" is the word she uses) by the prospect of taking possession of the studio space, and she manages in the process to reframe her sense of her own practice. As opposed to Gunning, who folds drawing into a performative language of the trace familiar to her, Smith relinquishes a spectacle-bound project altogether. She is essentially forced to do so by the residency. The collaborative enterprise of stage design – along with its architecture (wings, proscenium, lighting, props, costumes, and so on) – gives way to a carceral surround and a biographical chamber of personal memories. (But perhaps the public nature of the theatre and the private realm of the mind are not so at odds as one might initially assume. Think of Giulio Camillo who in the 1530s constructed a memory theatre, a work "of wood, marked with many images, and full of little boxes; ... He calls this theatre of his by many names, saying now that it is a built or constructed mind and soul....")[7]

To construct a memory chamber is no small undertaking. It seems clear, furthermore, that of the three artists, Smith was the most committed to creating and sustaining a state of radical introversion whose characteristics forcefully correspond to what Rilke described as the increasing rush of an "inmost life". When absorption counters theatricality in this way (Michael Fried's theory of pictorial modalities seems particularly appropriate here), objects and pictures accordingly jostle up against each other on walls in order to conjure up the real presence of past memories.[8] Each

element has its place in Smith's "internal dialogue" with herself: a drawn door next to a real door; a glass and a cigarette pack affixed to the wall next to a barely visible image made with a yellow fluorescent marker; actual grass turf, a white on white drawing of scissors, and the architectural model of a cityscape. However hermetic, these are the representational and material fragments that allow a private life, along with its traumas and gentler moments, to be reconnoitred and corralled as part of that extended reality made possible on paper. As with Heath and Gunning, things are left deliberately incomplete and the difficulty of approaching certain subjects is emphasised. And while the visitor to these three exhibitions may expect something more definitively worked out, it strikes me that there is something deeply satisfying about these experiences of drawing as both serious work and unfinished business. After all, what better means of affirming that drawing will never renounce its function as the pulse taker, as it were, for even the most contemporary of artistic gestures?

Erika Naginski

1 Rilke, Rainer Maria, "Progress", *The Book of Images*, Edward Snow trans, New York: Farrar, Strauss and Giroux, 1991, p. 91.

2 Gombrich, E H, "Leonardo's Method for Working Out Compositions", *Gombrich on the Renaissance: Norm and Form*, 1966, London: Phaidon Press, 1998, p. 61.

3 Greenberg, Clement, "The Great Precursor: Review of *The Drawings of Leonardo da Vinci* introduced by A E Popham", in O'Brian, John, ed, *Arrogant Purpose, 1945-1949*, Chicago: University of Chicago Press, 1988, p. 110.

4 See Damisch, Hubert, *Traité du Trait: Tractatus tractus*, Paris: Réunion des musées nationaux, 1995, pp. 59-60. See also Monbeig Goguel, Catherine, "Le tracé invisible des dessins de Raphaél: Pour une problématique des techniques graphiques à la Renaissance", in Hamoud, Micaela Sambucco and Strocchi, Maria Letizia, eds, *Studi su Rafaello*, Urbino: QuattroVenti, 1987, pp. 377-389.

5 de Piles, Roger, *Cours de peinture par principes*, Paris: Estienne, 1708, p. 260, p. 263, cited in Jacqueline Lichtenstein, *La couleur éloquente*, Paris: Flammarion, 1989, pp. 172-173.

6 Walker Bynum, Caroline, "Wonder", *American Historical Review*, 102/1, 1997, p.23.

7 Cited in Yates, Frances A, *The Art of Memory*, Chicago: University of Chicago Press, 1966, pp. 131-132.

8 Fried, Michael, *Absorption and Theatricality: Painting and Beholder in the Age of Diderot*, Chicago: University of Chicago Press, 1980.

Lucy Gunning's exhibition

Contributors

Irene Amore is a freelance writer and independent curator. From 1994 to 1996 she worked in commercial art galleries in Italy. Since arriving in London in 1997, she has organised grass-roots exhibitions in disused spaces and artist-led galleries. She is editor of the on-line magazine BTA (Bollettino Telematico dell'Arte), www.bta.it, and contributor to the art portals www.undo.net and www.exibart.com.

Neil Bartlett works as a performer, director, translator, author and designer. He is currently Artistic Director of the Lyric Hammersmith, where he has created seven pieces of work for the theatre with Rae Smith.

Hilary Baxter is a theatre and costume designer, a PhD student and Course Leader of BA Theatre Design: Costume Design at Wimbledon School of Art.

William Furlong is an artist. He established Audio Arts in 1973, which he continues to edit and produce from London. He works primarily in sound. Recent exhibitions include: *An Imagery of Absence*, Imperial War Museum, London, *Sound Garden*, Serpentine Gallery, London, participation in *Intelligence*, Tate Gallery, London, and a one-person show at the South London Gallery. He was Director of Research at Wimbledon School of Art at the time of the Claude Heath interview.

Michael Ginsborg has worked as an artist in London and in senior posts in UK art schools since the 1970s. As well as exhibiting his paintings and works on paper in galleries (Serpentine Gallery, Flowers East, Benjamin Rhodes, London, and in *The British Art Show* and *The Florence Biennale*), he has undertaken site-specific projects. He is represented by Rhodes+Mann Gallery, London; www.rhodesmann.com. Until summer 2002 he was Director of Studies at Wimbledon School of Art; he is currently responsible for the Centre for Drawing's future development.

Angela Kingston is a curator and writer. As Senior Researcher in Drawing at Wimbledon School of Art, she devised and ran the Centre for Drawing until summer 2002. Recent curatorial projects include *Girl*, New Art Gallery, Walsall, and tour (2000-2001), and *Somewhere: places of refuge in life and art*, Angel Row Gallery, Nottingham, and tour (2002-2003); recent writing commissions include essays on artists Hamish Black, Mariele Neudecker and Andrew Sabin.

Erika Naginski is Assistant Professor of the History of Art in the History, Theory, Criticism section of the Department of Architecture, Massachusetts Institute of Technology. Before joining the faculty there, she was a Junior Fellow at the Society of Fellows, Harvard University. Her essays have appeared in journals such as *Representations, Yale French Studies* and *RES*. She is currently writing a book on sculpture and the European Enlightenment.

Andrew Patrizio is Director of Research at Edinburgh College of Art, where he edits *292: Essays in Visual Culture*. From 2000 to 2002 he was also Associate Curator, Laing Art Gallery, Tyne & Wear Museums, Newcastle, where he curated the exhibitions *Life is Beautiful* and *All you need to know*. He has recently published a book on artist Stefan Gec, London: Black Dog Publishing Limited, 2002; and an article in *New Formations*, titled "A Phantom Limb: feeling the gap between invisibility and touch in recent British Art", Joanne Morra and Marquard Smith, eds, London: Lawrence & Wishart, 2002.